Rauschenberg

MODERN ARTISTS

Andrew Forge

Rauschenberg

HARRY N. ABRAMS, INC., PUBLISHERS, NEW YORK

Standard Book Number: 8109–4425–1
Library of Congress Catalogue Card
Number: 78–175944

63978

Contents

List of Plates

*Colorplates are marked with an asterisk**

Rauschenberg

MODERN ARTISTS

IN RAUSCHENBERG'S STUDIO there used to hang a small canvas called *White Painting with Numbers*. He has said that it was the first picture he ever did with which he could wholeheartedly identify. It was painted in 1949 while he was working at the Art Students League, and it seems that he painted it in a studio where Morris Kantor was holding a life class. The other students kicked up a fuss.

What was being protested against—the picture, or the nonchalance with which someone had turned his back on the class? Both, of course. If he had been eating a sandwich there or reading a book, there would have been no story. What the other students were facing was an ancient studio situation, that most problematic of all experiences open to a painter, which gets called "nature" but is really the whole of the history of art. Rauschenberg was refusing this challenge.

The point about the little picture that he worked on is that it was precisely true to the doubts that he felt. Incisive, positive in itself, it is genuinely noncommittal, culturally speaking. Monochromatic, it refuses the problem of tonality and color. Flat, it is true only to the canvas's tabletlike surface. It is indifferent to any spatial proposition except the fact that you can scratch through wet paint and expose the ground underneath. Its material consists simply of the physical properties of paint plus neutral symbols of information.

The episode of *White Painting with Numbers* epitomizes a great deal of Rauschenberg, his fastidious posture which includes both doubt and recklessness, diffidence and display. Is there not also in the picture itself, with its fretted key pattern that alternates between lines and boxes, figure and field, and its enigmatic tables of figures, something which foreshadows the qualities of his subsequent work? Neither composed in the way pictures are, nor reasonable in the way arithmetic is, it seems to open itself up, to face us with an extraordinary frankness, yet leave us suspended, asking questions and looking with enhanced vigor.

To draw anything—anyhow—is to comment upon it. There is no such thing as a neutral drawing, any more than there is drawing "as you see." This is not simply because of the infinite nuances of meaning that tradition has built into the conventions of drawing, but because a drawing is a closed system. Whatever is included in it is transformed by the system, made subject to it, and becomes more significantly a part of it than of anything else. It is like a state; its citizens are both subject to it and representative of it.

Everything that Rauschenberg did between *White Painting with Numbers* and the Dante drawings a decade later has the quality of an exploration outside the boundaries of this state. In the early fifties he had begun to collect objects in a spirit not far removed from the Surrealist *objets trouvées:* stones, timbers, and so on, sometimes isolated, sometimes juxtaposed, sometimes worked upon. At the same time he was deeply involved in photography, and photograms of various objects on blueprint paper were published in 1951.

The all-white paintings of 1952 and their all-black partners were the upshot of an experiment in painting—or rather, in the making of paintinglike surfaces—at the furthest perimeter of cultural language. They are on the brink of being not painting at all since a white wall or a tarred fence would have served some of their functions—except for the task given the onlooker.

The dirt paintings, which he made in the autumn of 1953, "canvases" of soil packed into chicken wire and stiffened with waterglass, randomly sprouting with birdseed and weeds, seem at first sight like attempts to test to the point of absurdity that tradition of modern art, exemplified by Klee, which claims the right for art to work with nature's laws. In fact they proceed from the opposite point, since what they demonstrate is nature working (as it must) as though it were a painting, not painting working (as it doesn't have to) as though it were nature.

With the black paintings, Rauschenberg said, he was "interested in getting complexity without their revealing much—in the fact that there was much to see but not much showing. . . ." They were constructed on a mosaic of newsprint, torn and crumpled and pasted onto canvas. This launched the painting, giving a lively vibrating surface within which "even the first stroke in the painting would have its position in a gray map of words." Gradually this base of "other" material began to establish an equivalence with the paint, to become as much of a subject as the paint, causing changes of focus.

The red paintings which followed were on a similar base, an active mosaic of collage; but almost at once the "changes

of focus'' were openly deployed. *Red Painting*, a long narrow canvas encrusted with an intense blood-red enamel over collage, has endpieces of raw wood. In another work of the same title, red fabrics—some striped, some patterned—are used alongside the paint as an equal factor. The underlying collage is allowed to show through more openly. In *Red Interior* the role of the disparate materials as subject is freely exposed and it would be impossible—and irrelevant—to say in what way the boards and notices, the fabrics or comic strips support the paint: they are on level terms with it.

Charlene, the climax of the red series, has a strong rectilinear and frontal structure. The irregular, boxlike supports, tightly packed, draw attention to their edges. One is conscious of their making, in their sum, the total outside shape of the picture, but the notion of a frame as a boundary between the picture and the outside world—an aesthetic threshold—has to give way to something much more complex. The frames and battens of *Charlene* articulate the *inside* of the picture; they also throw its boundaries far and wide. The wall behind insinuates itself through a hole in the picture and becomes a part of it. And as to the flashing light and mirror, one can imagine them as frames emerging from the picture out into the world, creating a new boundary for it in the space one is occupying oneself.

The concave mirror traps whatever is moving in front of the picture. A red dress or a white shirt, a turning reflection can be caught there swelling and shrinking on its polished curve. It is constantly moving, and by its agency the picture moves constantly too, each value that the mirror traps transforming the values that are painted or pasted in. A blue dress will flash like blue fire, inverting the warmth of the picture; bare arms, a spectacular suntan will spread a brilliant cinnamon that irradiates every red note there.

The real light in *Charlene*, inside the picture, puts us in a new relationship in which we might wonder which side of the frame we are standing on. In Amsterdam, where the picture now hangs, the light is high and flat and the flashing bulb is like a sharp, dry point. Elsewhere one has seen the surface of the picture modeled by the light, glistening, dulling, glistening, as it has flashed on and off, and has seen the picture suddenly take on the tawdry inertia of a bedroom wall flicked by neon across the street.

More than once Rauschenberg has related his intentions at the time of the all-white and the all-black paintings to the teaching that he received from Josef Albers. He had enrolled in Albers' class at Black Mountain College, North Carolina, in the autumn of 1948 after having read about him when he was in Paris. He was only with him for a short time.

Albers had shown that no color or set of colors was "better" than another, that anything could be made to work with anything else, given a sufficiently sensitive empiricism. This seemed to make the responsibility for choice a matter of individual taste or expressive purpose. But Rauschenberg has said:

> I was very hesitant to just arbitrarily design forms and select colors that would achieve some preconceived result, because it seemed to me that I didn't have any ideas that would support that. I had nothing for them to do so I wasn't going to hire them. I was more interested in working *with* them than in their working for me.

The further the implications of what Albers said were pressed, the more his case seemed to threaten the individual integrity of colors. There is a passage in *The Interaction of Color* where Albers suggests the image of colors as actors and different color arrangements as performances, for which the stage is the format.

> Acting in visual presentation is to change by giving up, by losing identity. When we act, we change appearance and behavior, we act as someone else. . . . Color acts in a similar way.

With which statement we may juxtapose Rauschenberg's remark:

> . . . I didn't want painting to be simply an act of employing one color to do something to another color, like using red to intensify green, because that would imply some subordination of red.

Paradoxically, considering their minimal chromatic qualities, the white and black paintings were concerned, among other things, with the reinstatement of color. Their "emptiness" was simply the outcome of using color in stasis. Nothing is set in motion inside the picture, so nothing moves at the expense of anything else. At the same time, these pictures established two positive factors in relation to color which he was to explore in detail in the next few years. The first has to do with the color of actual things, self-color.

If we say "a white canvas," we think of a bare canvas ready to be painted on—an object. If we say "a white painting," we think of a painting in which white is the predominant color, either in area or activity, an art work, in a different category from an object. What Rauschenberg's all-white paintings did was to allow him to see the self-colors of an object as pictorial color; and to claim for his pictorial color choice the unnegotiable integrity which is the attribute of objects. The white of the white paintings had to meet the world as a worldly fact, not as part of a system, isolated from the inroads of contingency, and yet at the same time vulnerable to them. What is at issue here can be brought into focus by thinking of the experience of looking at a picture in changing light. As the daylight begins to go, we have the sense of something failing, being brought to a standstill. It is not that we lose touch with the picture as a physical object, but that our communication with it is interrupted, just as a jet plane might interrupt our communication with a string quartet. It is its sense which slowly disappears. Not so the room in which it hangs. It is still there and our relationship to it is changed but *not interrupted*.

The other lesson in regard to color stemmed from the experience of the all-black paintings. They were made up of a dense collage of papers, across which and around which and within which the black paint was applied in a varied range of densities and textures. The result was an extremely wide range of blacks, a chord of blacks in which each condition of paint and of newsprint under it contributed a specific vibration. All one color by any reasonable count, they were in effect as varied and as nuanced as if there had been many. Texture, surface, application—all had contributed a special timbre. There was no such thing, then, as a single color in different states; there was nothing provisional about any particular embodiment. How it happened *was* the color. And subsequently it is impossible to say much about Rauschenberg's color without also discussing whatever it is that is colored, whether one is talking about objects or about paint. It was on the basis of this view of color as an attribute of real things rather than as an idea or an essence, a privilege of painting, that he came later to absorb such a fantastic range of objects into his palette.

Nothing that Rauschenberg has done has been detached from an immediate context. He carries his work with him. He is the opposite of the kind of artist whose studio is like a hermit's cell or a laboratory, the only place where things are "right" and work can get done. Rauschenberg has worked in front of audiences and in museums, backstage in theaters, and in hotel bedrooms. If the situation has been intimidating or inconvenient, that in itself has been accepted

as a formative ingredient, not as an excuse for stopping. Life has penetrated his work through and through, and each work, rather than imposing a definition of art, springs from a question about the possible contexts in which art can happen.

"Ideally I would like to make a picture [such] that no two people would see the same thing," Rauschenberg has said, "not only because they are different but because the picture is different." John Cage has spoken of a music which envisages "each auditor as central, so that the physical circumstances of a concert do not oppose audience to performers but disperse the latter around-among the former, bringing a unique acoustical experience to each pair of ears."

"Is a truck passing by music?" Cage asked in the same text. Are shadows passing by or sprouting bird seed painting?

Rauschenberg has used chance not as a blind antidote to order but as a way of handling the streaming autobiographic current that is his subject matter. Chance has meant selection, in fact, not chaos. Nor has he used it to exclusive ends, disguised as a system with its own rules and its own internal determinants. It has been a concrete alternative to the problematic confrontations of the studio, an open horizon. If something just happens it is, from his point of view, more convincing than something longed for or willed that doesn't happen.

When he was building one of the sections of the Amsterdam *Dylaby* he was offered the run of a junk yard for material; he was nonplussed. He had not realized until then how much it had meant to him that his objects had just turned up—if not today, then tomorrow. He was not keen on having to select.

When he first worked on silk screens with color he had found it difficult to reconcile himself to the blatant unpleasantness of the silk-screen inks, until he had established that there were only certain colors available, that they were the only ones to do the job, and that, raucous as they were, they could not be improved upon. Then even the screaming pink became possible, because it had taken on the status of a thing.

Whatever stratagem is used to court the unknown, there comes a point at which random material becomes polarized by the particular energy that is brought to bear on it. This is the paradox that fascinates him. He is equally sensitive to both extremes, to what he has called the "uncensored continuum" and to the finest aesthetic precipitation of it. His nonchalance is anything but evasive: it signifies a determination to accept *total* responsibility for what he does and to allow no prejudice, no *parti pris* to scatter this allegiance.

Of course there are preferences, favorite preoccupations, both formal and iconographic. The trailing horizontal line that wanders across so many canvases, a certain crispness around the edges of things, dearly held icons—birds, umbrellas, the Statue of Liberty—and to some extent these favorites threaten the freshness of his contact with material. More than once his obsession with biographical honesty has landed him in a seriocomic dilemma. A certain project involved the juxtaposition of a fountain and a clock. How was the clock to be kept dry? The obvious solution seemed to be some form of umbrella. But its obviousness was suspect. Was it more truthful to accept the personal cliché for the sake of the objective function, or to go on searching for a more recondite solution? Similar scruples surrounded his use of silk screens of President Kennedy, after Dallas had charged that likeness with an unforeseeable weight. He came to the conclusion that it would have been just as affected to have dropped it at that point as it would have been to have started to use it then.

Making or performing has for Rauschenberg the value of a kind of giving. Many of his works have a personal direction, and are, so to speak, addressed like presents. There was an occasion when a combine was made for an exhibition which secretly incorporated works by two other painters who had been rejected from that exhibition; his own work served both as a sheltering vehicle for them and as a voice raised on their behalf. The idea of collaboration with others has preoccupied him endlessly, both through the medium of his own work and in an open situation in which no single person dominates. In *Black Market* he invited the onlooker to exchange small objects with the combine and to leave messages.

Painting is autobiographical, "a vehicle that will report what you did and what happened to you." Several works of the mid-fifties bear out this claim; for instance, the second version of *Rebus*, called *Small Rebus*. Above the row of color samples that divides the canvas laterally, is a photograph of a single runner curving past an audience of figures in suits seated on a rostrum. Below, three athletes perform on a rope. Related to them is a photograph of what appears to be an ancient brooch representing a dog, its coiled limbs echoing the coiling athletes, and to the extreme left, a fragment of another gym picture just showing a handstand. At the right edge of the canvas is a family group, a snapshot, the father in shirt sleeves and hat, his feet apart, his shoulders high; the mother craning forward with her hands on the shoulders of a bare-footed eight-year-old girl. Beyond are trees and an open prairie.

The center of the canvas is pale, with pasted papers and overlapping gauzes and sparse scribbles of paint. One

element is a map, or rather two maps, a section of Central Europe and a section of the Middle West, pasted up to make one. Left of it, eight postage stamps. On the left edge is a detail from Titian's *Rape of Europa*, Europa herself, and above is a bullfight photograph, a corrida, and a child's drawing of a clock face with no hands.

One doesn't have to strain the material in the least to read it as a meditation on his own youth, his family past, his sense of identity. The family group is the only image which is unbroken by paint or anything else. It has peculiar sharpness. The single runner, at full stretch in front of his audience of judges, is ringed in black. The implications of identity are inescapable. Geography and history are implicit; athletic performance takes on the value of an individual life.

In the winter of 1958–59, Rauschenberg started to work on a series of drawings illustrating Dante's *Inferno*. He had found that it was possible to take a rubbing on paper from newsprint wetted with lighter fuel. The resulting impression could be amalgamated with other graphic media—with pencil, watercolor, crayon, and collage. His palette was now extended to include a vast range of printed material, limited only by the degrees of solubility of different printing inks.

He set himself to work exactly to the form of the poem, not to select particular passages, not to make a personal anthology from its images, but to make one whole drawing from each whole canto, thirty-four in all; and in the same spirit, each drawing was to be an inclusive account of the canto, not a mere evocation of the more striking pictures from it. Thus the arrangement of each page corresponds with the spatial events of Dante's journey, and the particular images find their place in a complex compositional relationship which corresponds with the unfolding of the poem.

Dante's allegory was a model for the cosmos, an inclusive picture of man's relation to God and to his own soul, as well as a detailed critique of his social and political behavior. There are times when it is possible to imagine Rauschenberg relating himself to Dante as Dante does in the poem to Virgil. Dante's hardwrought and practical imagery is like a bond between them, affirmed in the way that Rauschenberg rises to the problem of finding a live equivalent to Dante's engagement with the affairs of his own time: centaurs become racing cars; the farting devils of Canto XXI become soldiers in gas masks; Richard Nixon, John F. Kennedy, and Adlai Stevenson stand in for Dante's contemporary political figures.

The transfer process had sprung a tremendous expansion of subject matter and put his hand on a seemingly inexhaustible richness. His use of silk screen in his painting follows from this.

In the silk-screen paintings he uses his material lavishly, like a man using his eyes and his other senses lavishly. The lights of the streets seem to stream through his studio just as once white shadows had flickered on the all-white canvases whose surfaces were opened to whatever came. Titles alone proclaim an engagement on a geographical scale. There is a picture called *Almanac*; others are *Creek, Overcast, Tideline, Sundog*.

In *Tideline* the following screens are brought together: top right, a section of ocean swell; center right, a helmeted fireman facing a blaze; bottom right, the foreshore of the Battery in New York City; below that, the dials of an aircraft and a football suspended in a field of white paint, anchored to a finger like a dirigible to its mast. To the elements— Earth, Air, Fire, Water—are added two factors of human control: Measurement and Art. Top left, a clock face; center left, a detail of Rococo molding. But the clock does not have numbers on it, and the legend printed above it reads "External Time Optional"; and the ceiling, its flowery convolutions bursting crisply through the veil of paint that frames it, is not so much an isolated art work as a florescence on the surface of the picture itself.

The movements of the silk-screen pictures are oceanic. They make concrete a fantasy of the bird's-eye view, a total experience of the world, not through the assumption of omnipotence, an imperial exercise of style, but through a larklike mobility that takes him threading through layer after layer of things, never at rest.

Barge, with which the first series of silk-screen pictures reaches its climax, deals with communication (antennas, roads, signals), physical prowess (football, swimming), discovery (space rockets, fly, latch key), places. The paint, brushed freely, dripped, splashed, sometimes roughly drawn, provides an active but stabilizing fabric within which the silk screens are articulated across the canvas's enormous length. At times the paint intervenes pointedly, contributing to the imagery, exploding here in a flare of light like a firework, elsewhere streaming in veils like rain.

Barge is encyclopedic. Like an atlas it holds out a promise of the entire world. There are intimations of weather, of day and night, of the seasons. Vast pictorial spaces are suddenly fixed, cut to size with a screen—which in turn evokes vast spaces—only precisely, outwardly, as defined in the rolling perspective of clouds or the frame of a half-completed building. A sense of place yielded by a photograph continually telescopes into a sense of infinity. And all over there is the recurrent theme of human structuring, communication, interpretation, purposeful and beautiful engagement with the world: the swimmer ploughs the water, antennas scan, the print of the painter's hand marks the bottom edge of the canvas.

Ever since the fifteenth century artists have worked with a concept of wholeness. It has been at the center of almost

every definition of art. "A work is finished only when nothing can be added and nothing taken away except to the detriment of the whole": Alberti's formulation is still self-evident. Completion implies a self-contained organism whose internal structure sets it apart from "life" or "contingency" or the "world." This is so whether one is approaching the work from the position of its formal relationships or whether as a system of spiritual or psychological truths. In either case it is the totality of the work which justifies whatever claims it makes, gives it its standing over against the contingent, sets it apart, charges it.

The white paintings which Rauschenberg exhibited in 1953 announced a radical alternative. In a sense they were whole from the outset—they had been white canvases all along—and this "wholeness" could hardly have been modified by what was added. Painting them was an almost invisible affirmation of what was already there. By the same token, as they continued to be what they had always been while he worked on them, they underwent none of that removal from the contingent that the completion of a work normally implies. They ended up as open as they started. Paradoxically, nothing was excluded from them, because nothing was included. And by refusing every articulation or accent from the field of art, Rauschenberg was accepting whatever articulation or accent the world happened to endow them with:

> I always thought of them as being not passive but very hypersensitive, so that any situation that they were in one could almost look at the painting and see how many people there were in the room, by the number of shadows cast, or what time of day it was, like a very limited kind of clock.

He was establishing an unprecedented degree of mutuality between the picture and its surroundings. Imagine a roomful of white canvases: we maneuver in front of them, expectations alert. Our shadow crosses them: they had been empty art-supports; now they vibrate, respond with the shadow of our presence. White is no longer a color like a sign but a drawn-out event which, starting at the brilliant edges, burrows deep into a furry gray, the center of our own penumbra. They are big enough to hold us and they move as we move, staying white.

It is an occasion which renews itself, with no carry-over, no idealistic message. It has simply to do with our awareness. Fifteen years later he was to mount a kind of electronic reprise of the white paintings. Spectators in a gallery found themselves looking at their own reflections in dark, scratched mirrors running the length of the room. Then as they talked or shuffled or coughed, their reflections were joined by the flickering, running images of white wooden

chairs, piled up somewhere behind the mirrors. Overhead microphones, covering the entire gallery space, picked up sound and had triggered systems of lights buried among the chairs. It was as though the dimensions of the room, and even its stability were at the call of the slightest noise, unwitting or intentional, that the spectators made. They ended up using their eyes to attend to their own sound.

Works of art get used. At one level he will explore this fact critically in his work; at another he will act it out, as though through a charade. Such has often been the character of his exhibitions. There was one, for instance, when, as a corrective to what seemed to him an overly casual, stereotyped reception of current shows, he arranged with the Leo Castelli Gallery that instead of announcing a one-man show in the usual way he insinuate more and more of his pictures into a mixed exhibition, then replace these paintings with combines, thus holding an exhibition virtually unannounced and one of which nobody who saw it could be certain that he had seen the same show as anybody else. Again, private usage has provided fresh material: the chair found its way into *Pilgrim* because, on a visit to a collector's apartment, chairs had to be moved in order to see the pictures. *Pilgrim* solves this particular problem. More than once he has painted in front of an audience. It has always been an enigmatic performance: in Paris the audience saw the back of the canvas only, and heard the painting through microphones wired to it. In Japan he answered the questions of an eager audience by doing things to a painting. And repeatedly and sometimes for long periods he has given much of his time to the stage.

Rauschenberg has assumed that there is no aspect of art which does not demand examination; that to work under the spell of received ideas is to be less than free; that this applies as much to the social definition of art as to studio definition. He has seen to it that the world, that which is the case, is active *at every point* in his work. "I think the whole process of painting is a very local involvement," he told David Sylvester in a conversation in the course of which he stressed the way that the usage of art speeds up its decay.

> Actually I like all the investigation . . . that happens now. One looks forward to a painting finishing itself . . . because if you have less of the past to carry around you have more energy for the present. Using, exhibiting, viewing, writing and talking about it is a positive element in ridding oneself of the picture. And it does justice to the picture that defies this. So that you may not accumulate mass as much as you may accumulate quality.

Plates

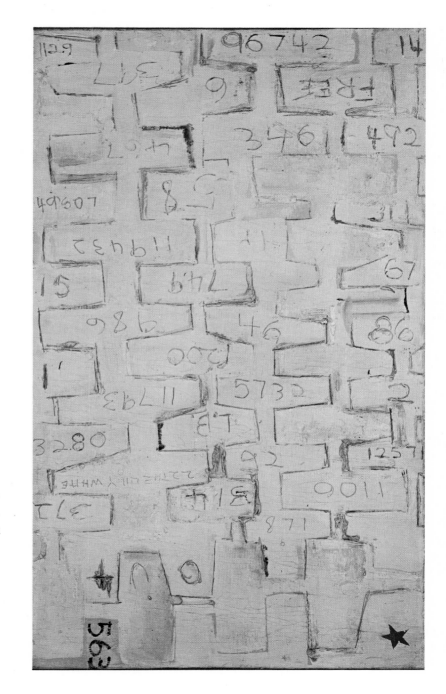

1. *White Painting with Numbers*. 1949.
Oil and pencil on canvas, 39 1/2 × 23 1/2″.
Collection Mr. and Mrs. Victor W. Ganz, New York

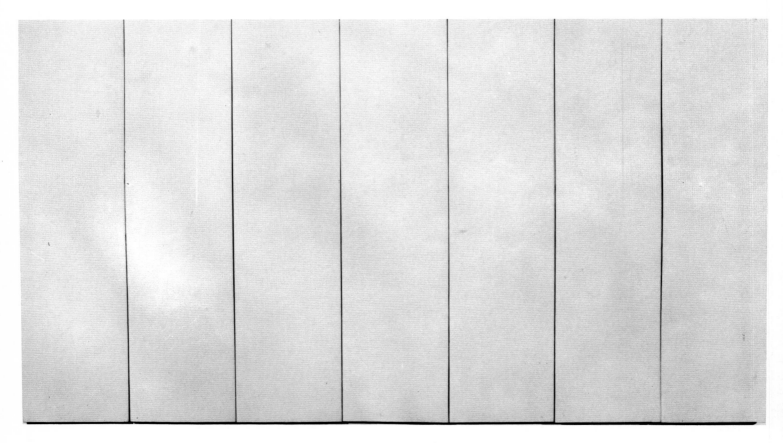

2. *White Painting (Seven Panels)*. 1951. House paint on canvas, 6′ × 10′6″. Collection the artist

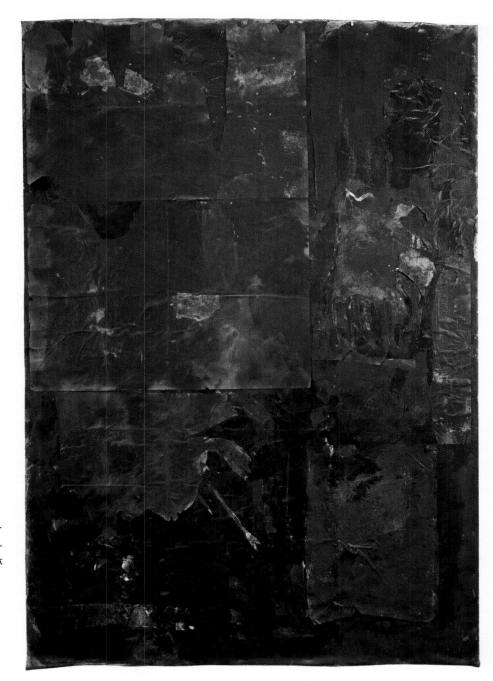

3. *Black Painting*. 1952.
Combine painting, 72 × 54".
Collection Morton Feldman, New York

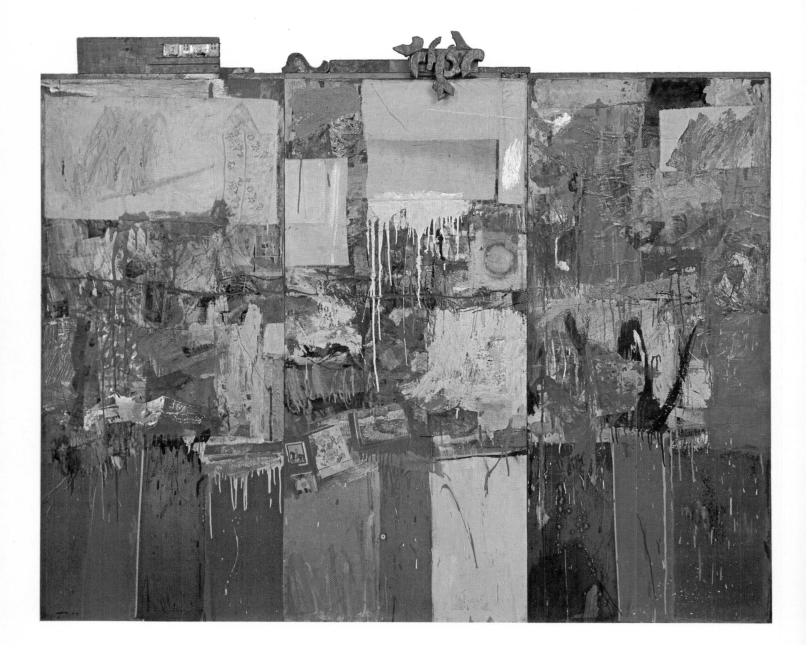

4. *Untitled.* 1953–54.
 Combine painting, 75 × 96".
 Collection Michael and Ileana Sonnabend, Paris

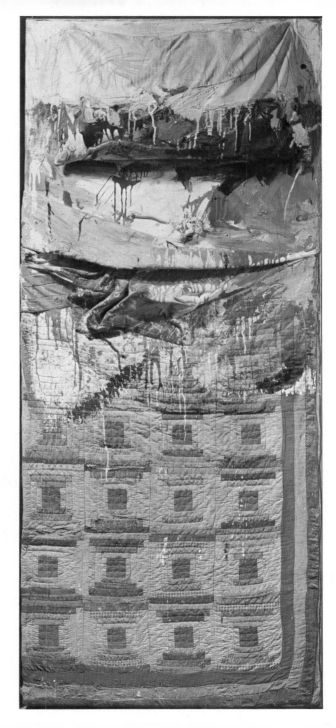

5. *Bed.* 1955.
 Combine painting, 74 × 31".
 Collection Mr. and Mrs. Leo Castelli,
 New York

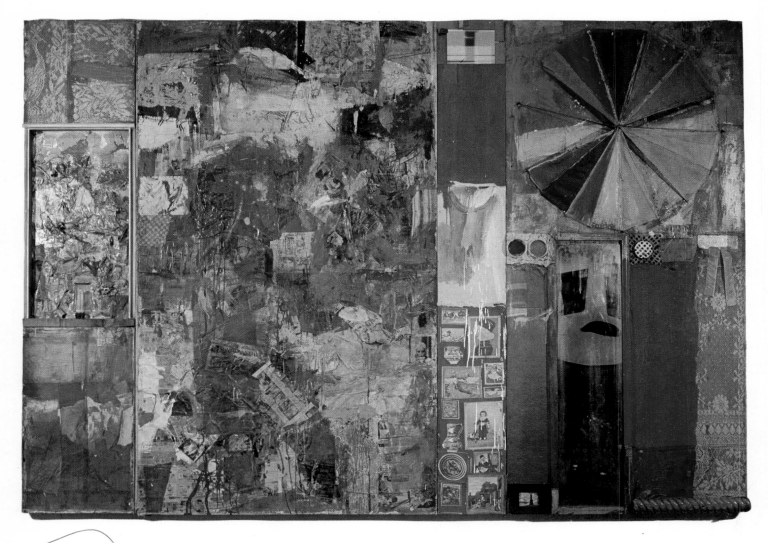

6. *Charlene*. 1954. Combine painting, 7′5″ × 9′4″. Stedelijk Museum, Amsterdam

7. *Red Interior*. 1954. Combine painting, 56 1/2 × 61 1/2″.
Collection Mr. and Mrs. Victor W. Ganz, New York

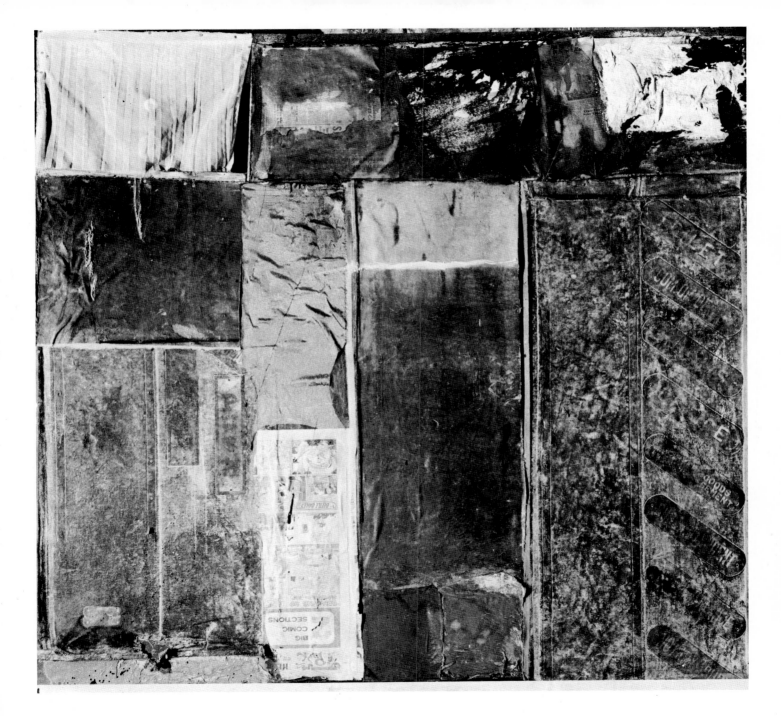

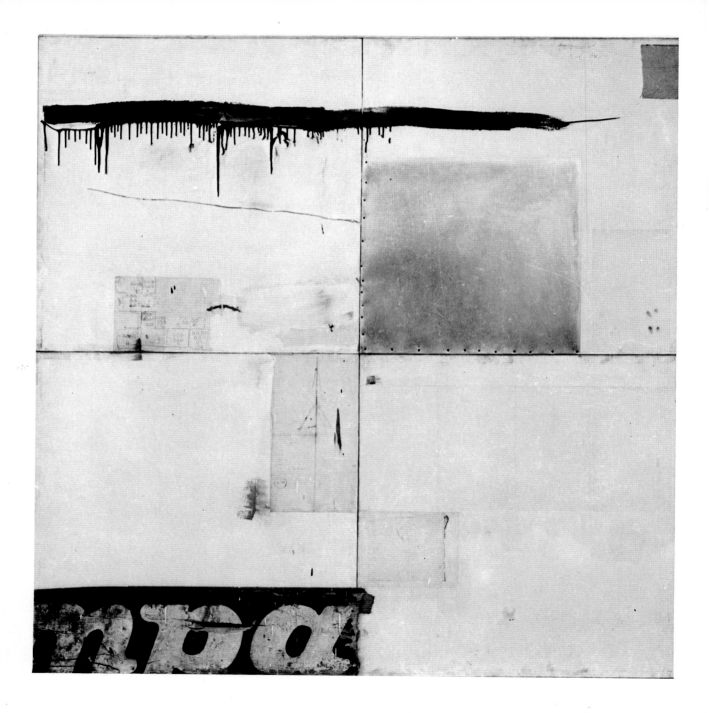

8. *K24976S*. 1956.
 Combine painting, 72 × 72″.
 Collection Richard Miller,
 Philadelphia

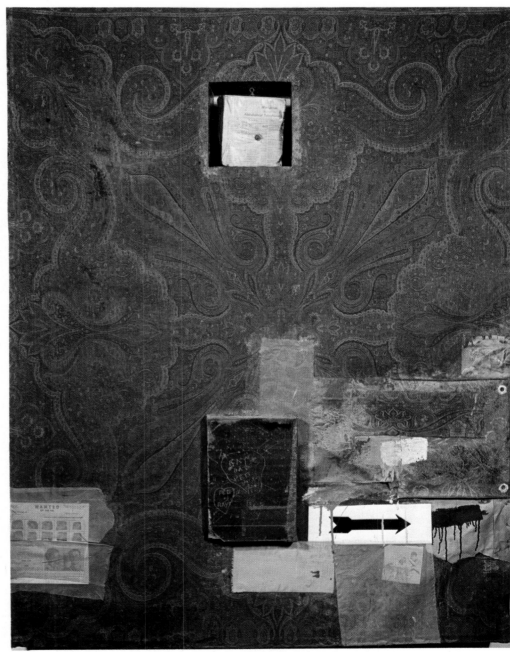

9. *Hymnal*. 1955.
 Combine painting, 65 × 60″.
 Collection Michael and
 Ileana Sonnabend, Paris

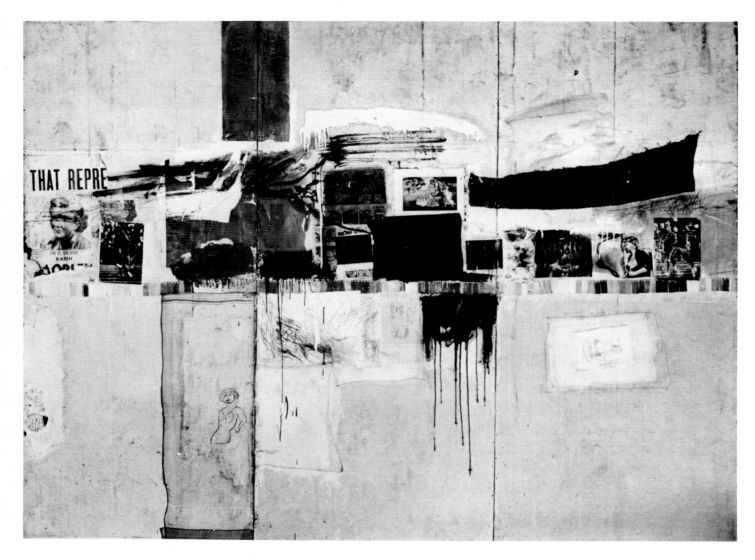

10. *Rebus*. 1955. Combine painting, 8 × 12′. Collection Mr. and Mrs. Victor W. Ganz, New York

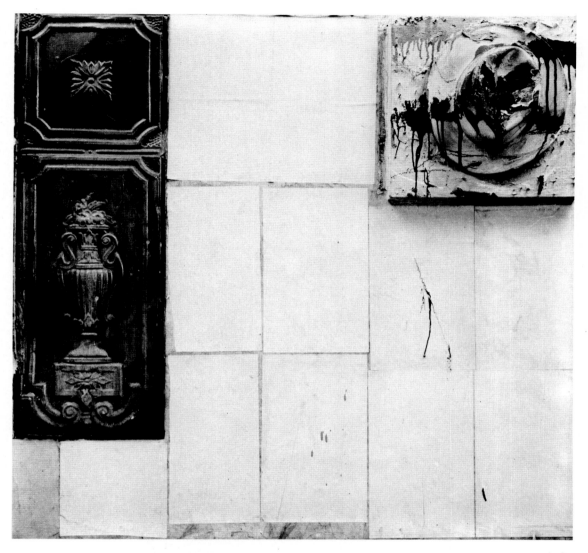

11. *Interior*. 1956. Combine painting, 45 × 46 1/2". Collection Michael and Ileana Sonnabend, Paris

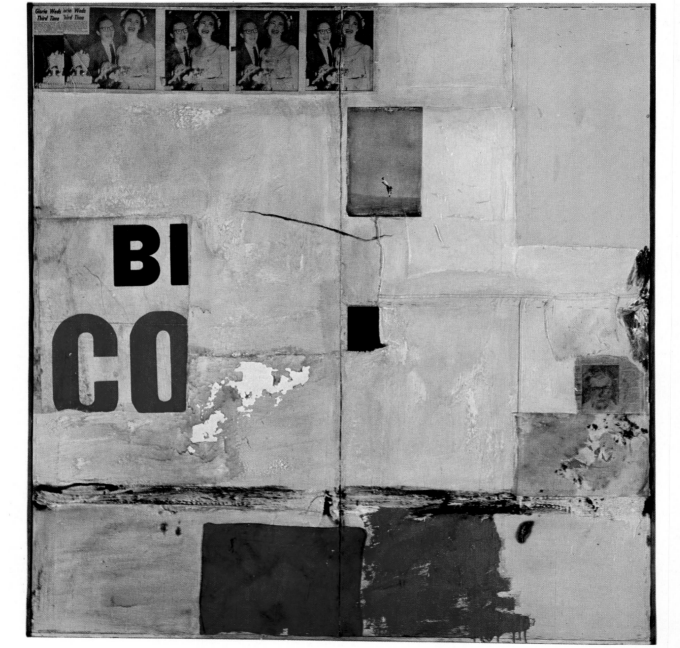

12. *Gloria*. 1956. Combine painting,
66 1/2 × 63 1/4″.
The Cleveland Museum of Art.
Gift of the Cleveland Society
for Contemporary Art

13. *Memorandum of Bids*. 1956.
Combine painting, 59 × 45″.
Collection Michael Sonnabend, Paris

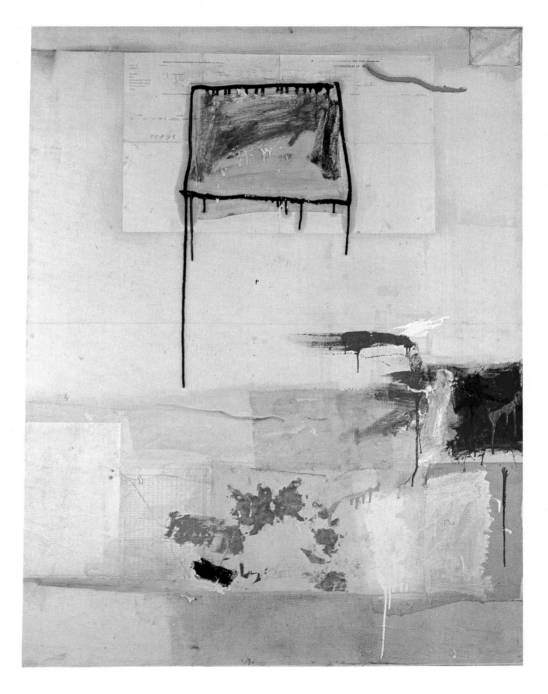

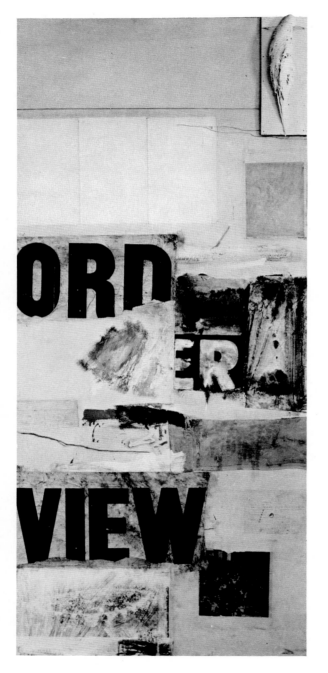

14. *Hazard*. 1957. Combine painting, 85 × 37".
Collection Wolfgang Hahn, Cologne, Germany

15. *Small Rebus*. 1956. Combine painting, 35 × 48".
Collection Count Panza di Biumo, Milan

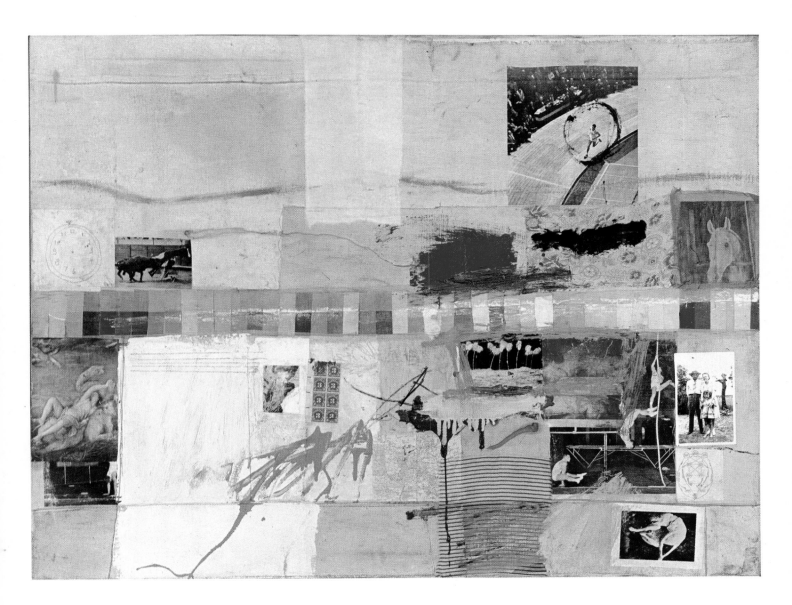

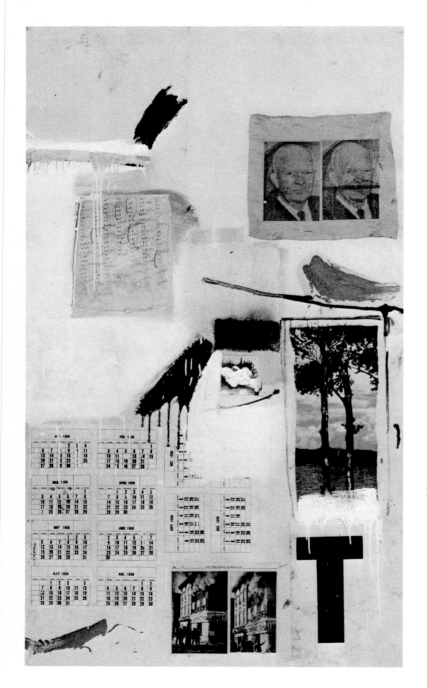

16. *Factum II*. 1957. Combine painting, 62 × 35 1/2″.
Collection Mr. and Mrs. Morton G. Neumann, Chicago

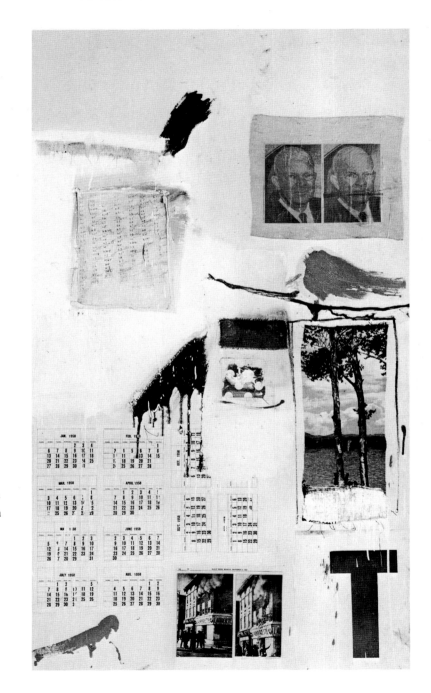

17. *Factum I.* 1957. Combine painting, 62 × 35 1/2″.
Collection Count Panza di Biumo, Milan

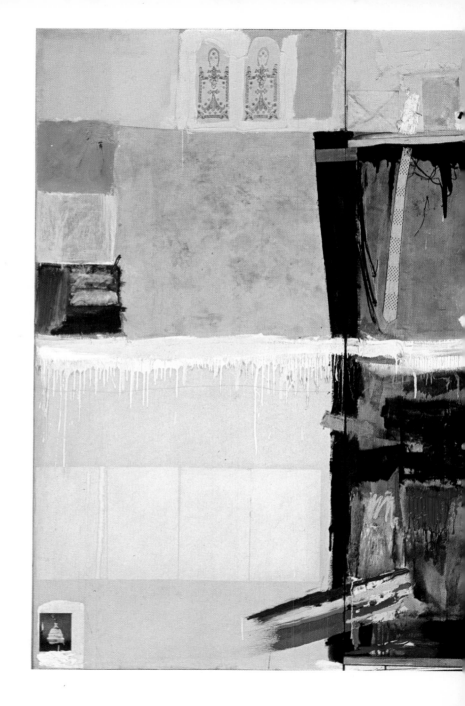

18. *Wager*. 1957–59.
Combine painting, 6′9″ × 12′4″.
Kunstsammlung Nordrhein-Westfalen,
Düsseldorf, Germany

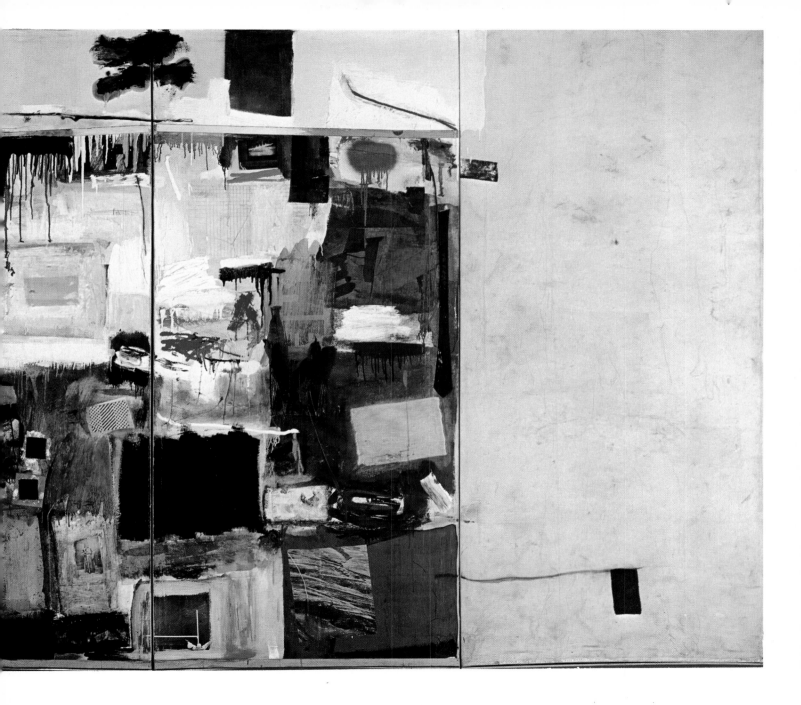

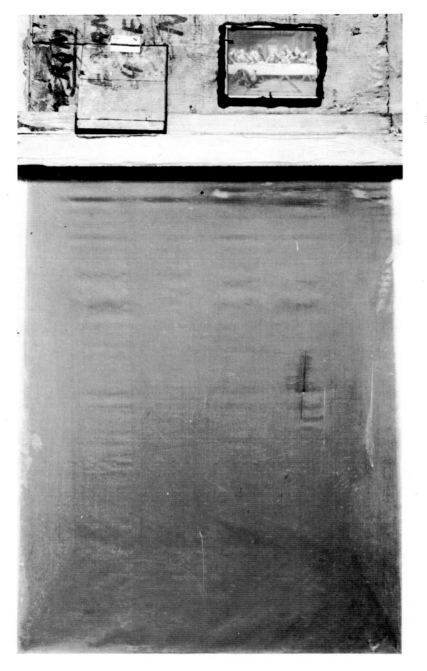

19. *Odalisk* (detail). 1955–58. Construction. Collection Mr. and Mrs. Victor W. Ganz, New York

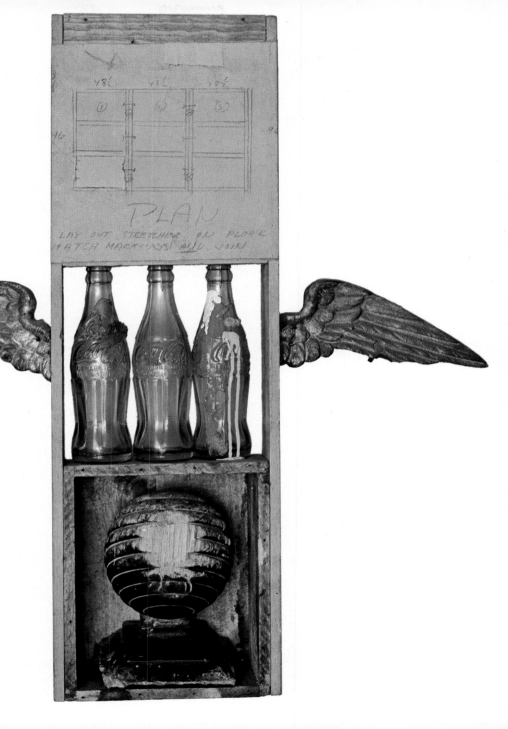

20. *Coca Cola Plan*. 1958.
Combine painting, 26 × 6 × 4".
Collection Count Panza di Biumo,
Milan

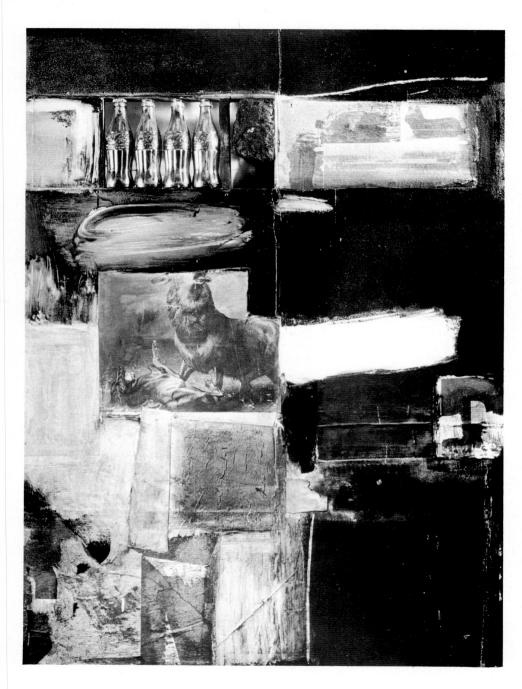

21. *Curfew*. 1958.
Combine painting, 57 × 39″.
Collection Mr. and Mrs. Ben Heller,
New York

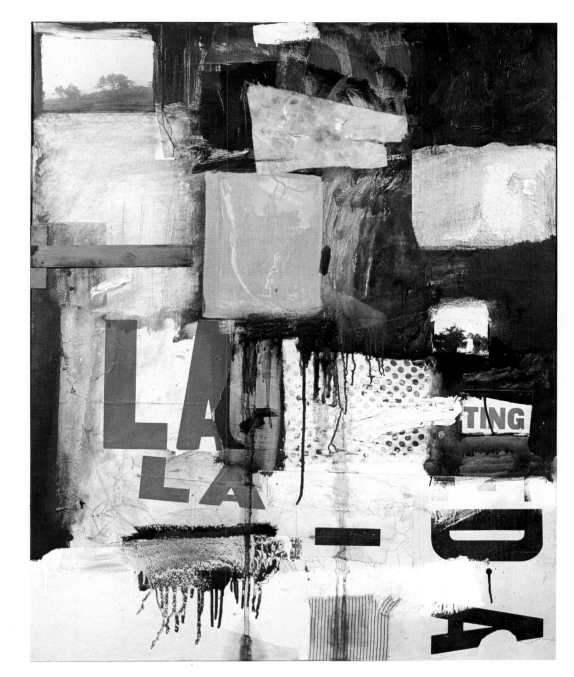

22. *Thaw*. 1958.
Combine painting, 50 × 40″.
Collection Mr. and Mrs.
Robert C. Scull,
New York

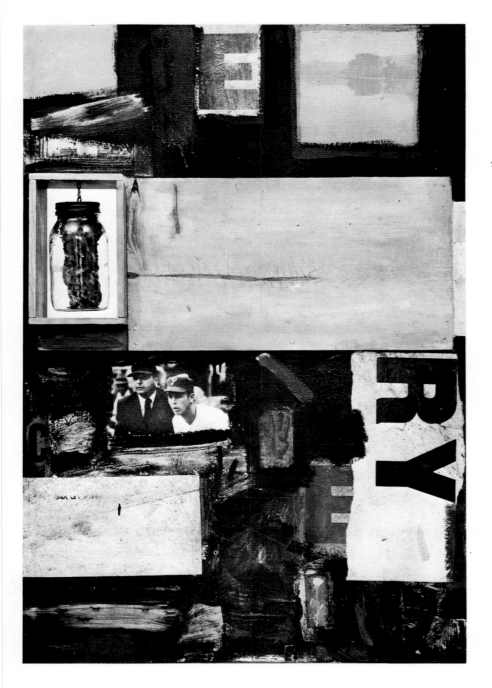

23. *Talisman*. 1958.
 Combine painting, 42 × 28″.
 Collection Mr. and Mrs. Arnold Maremont,
 Winnetka, Illinois

24. *Photograph*. 1959.
Combine painting, 47 × 55″.
Collection Mr. and Mrs. Donald M. Weisberger,
New York

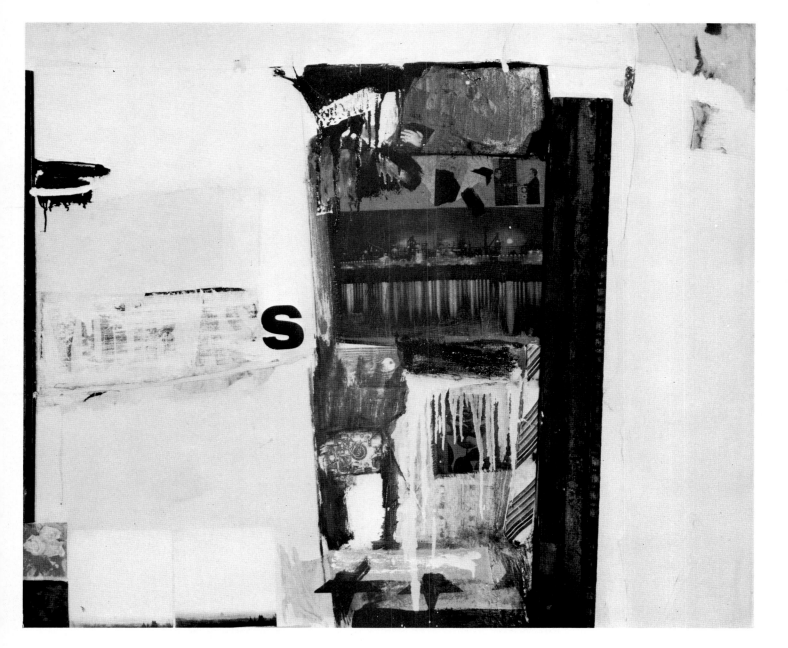

25. *Monogram*. 1959. Construction, 48 × 72 × 72″.
Moderna Museet, Stockholm

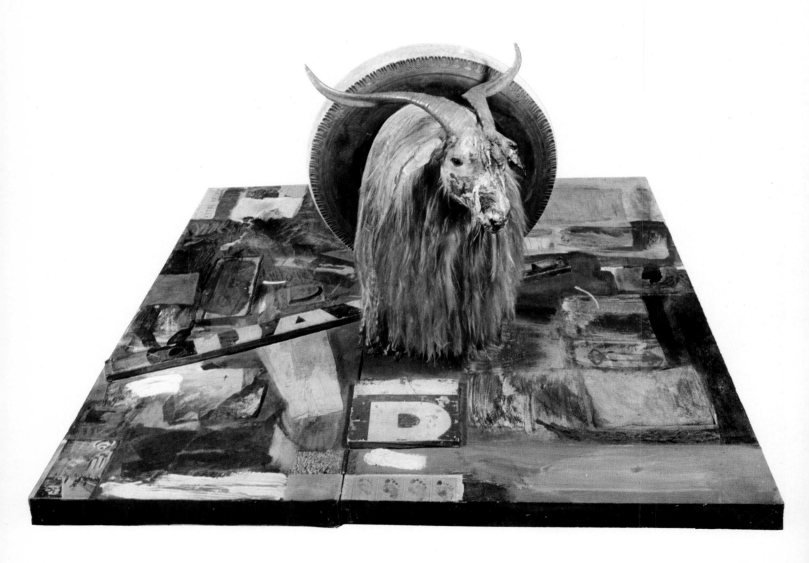

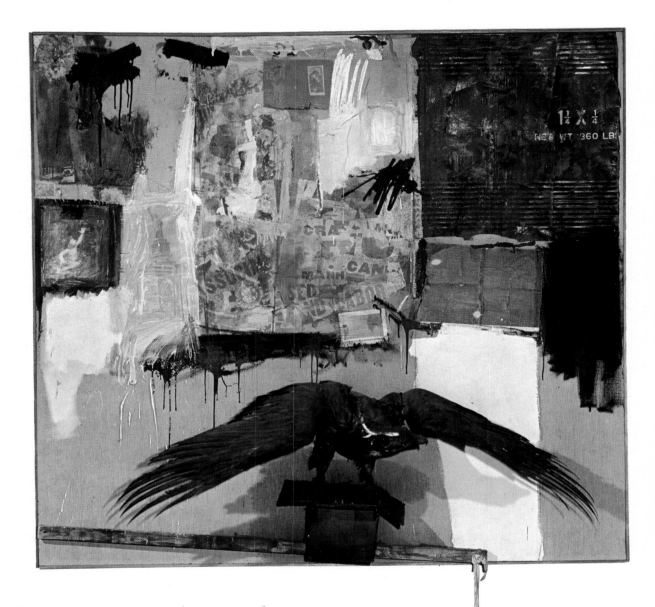

26. *Canyon*. 1959. Combine painting, 86 1/2 × 70 × 23".
Collection Michael and Ileana Sonnabend, Paris

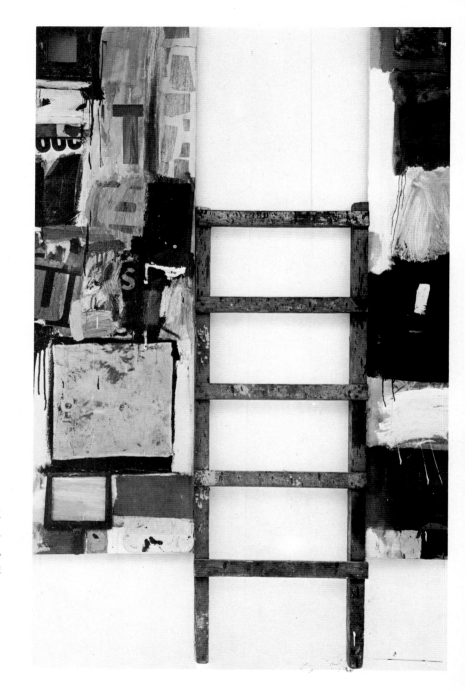

27. *Winter Pool*. 1959.
Combine painting, 88 1/2 × 58 1/2".
Collection Mr. and Mrs. Victor W. Ganz,
New York

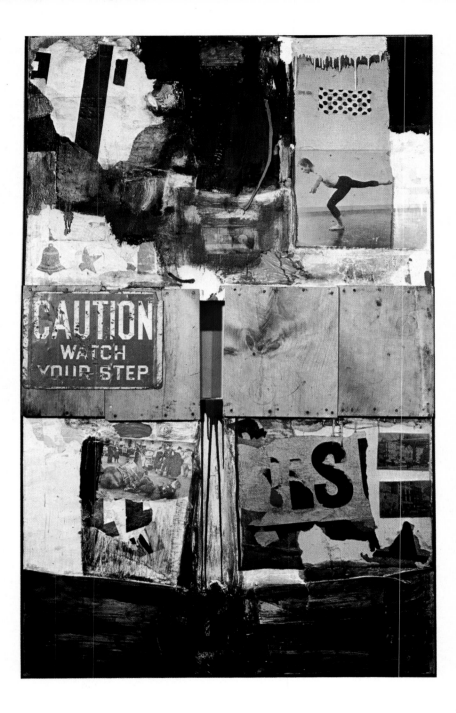

28. *Trophy I (For Merce Cunningham)*. 1959.
Combine painting, 66 × 41″.
Private collection

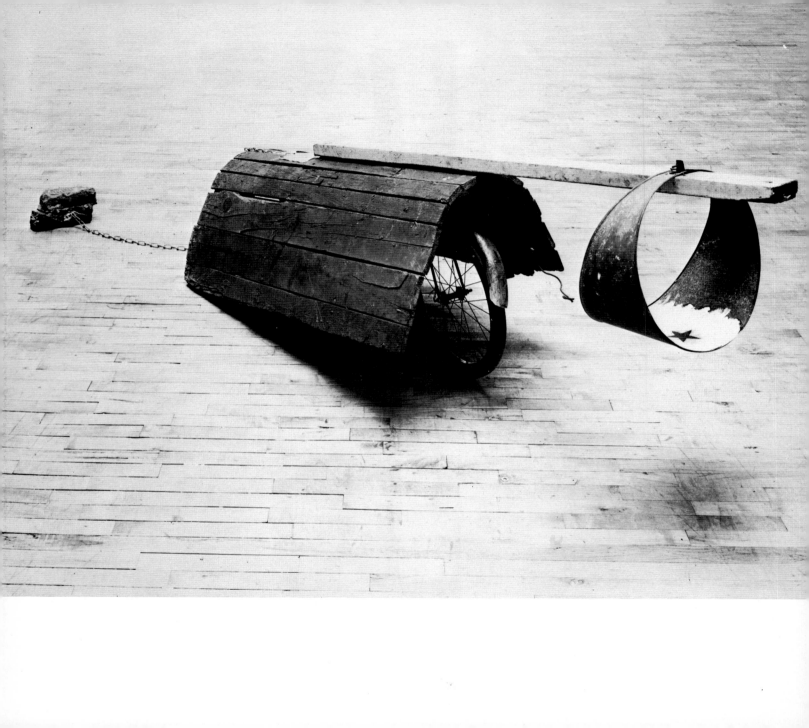

29. *Empire I*. 1961. Construction, 33 × 82 × 28″.
Collection the artist

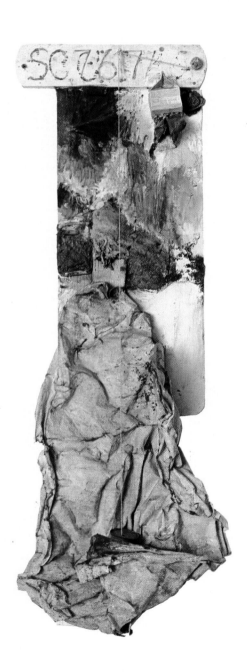

30. *Slow Fall*. 1961. Construction, 59 × 20 × 8 1/2″.
Collection Count Panza di Biumo, Milan

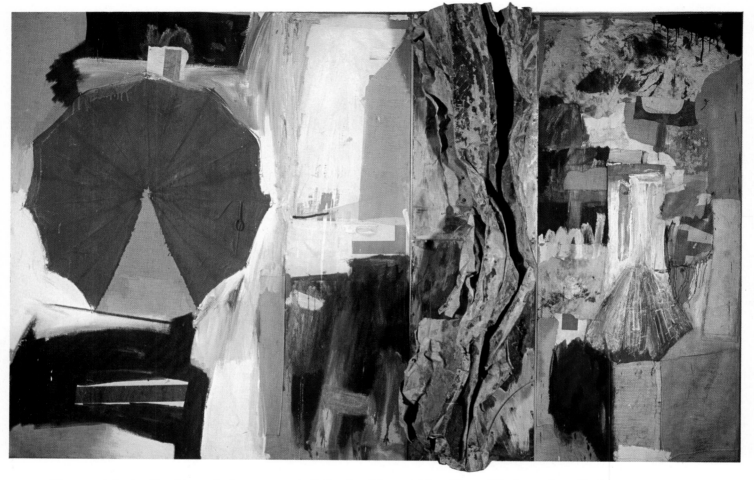

31. *Allegory*. 1959–60. Combine painting, 6 × 10′. Collection Mr. and Mrs. Victor W. Ganz, New York

32. *Wall Street*. 1961. Combine painting, 72 × 89″.
Leo Castelli Gallery, New York

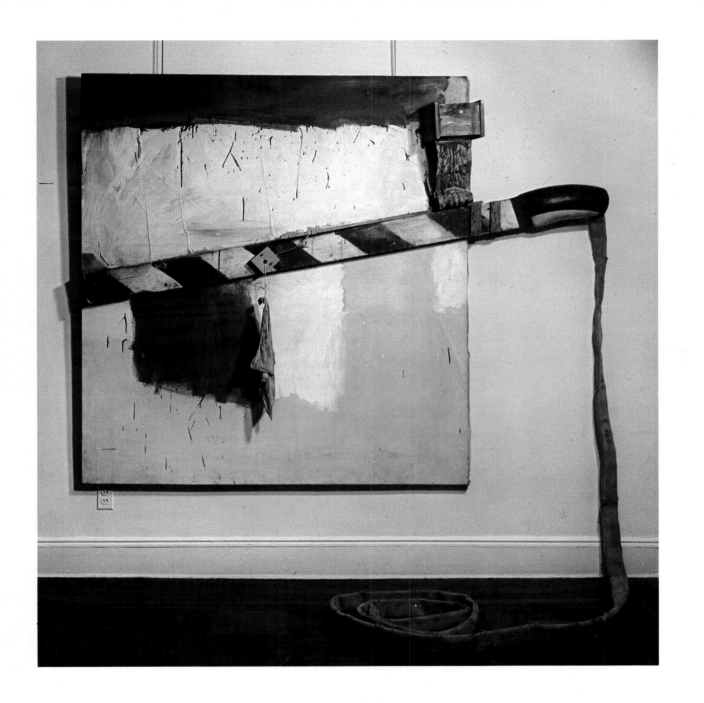

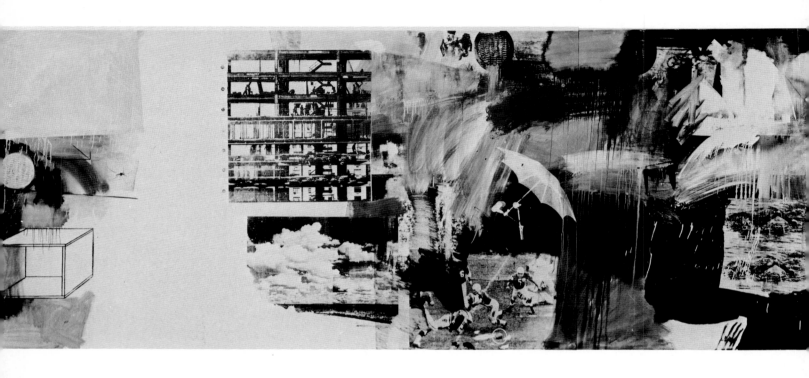

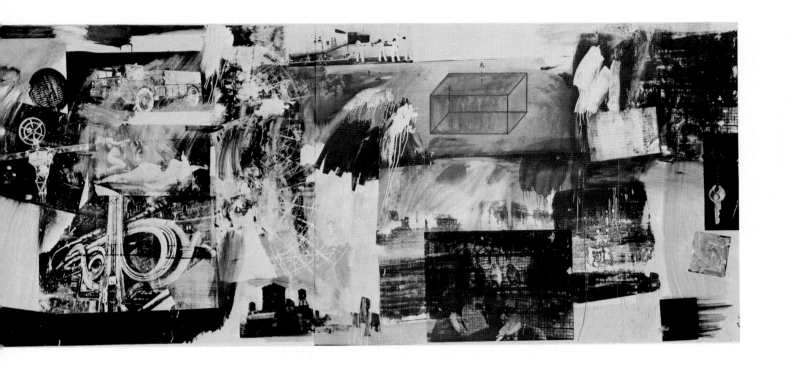

33. *Barge*. 1962. Oil on canvas, 6′6″ × 32′2″. Collection the artist

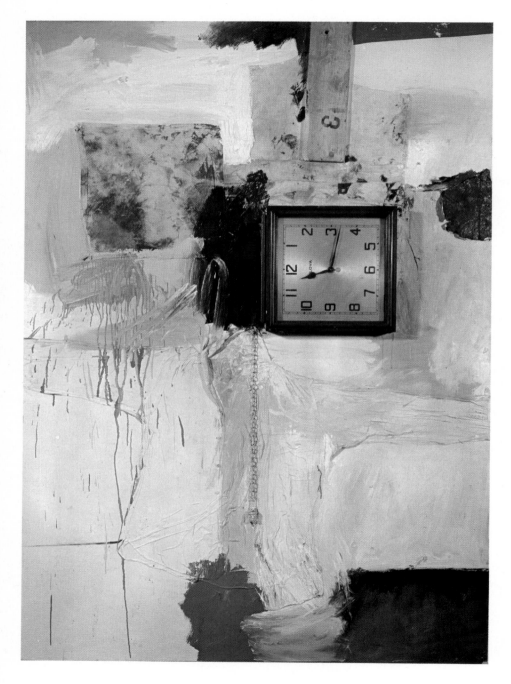

34. *Third Time Painting*. 1961.
Combine painting, 84 × 60″.
The Harry N. Abrams Family
Collection, New York

35. *First Landing Jump*. 1961.
Combine painting, 89 × 72″.
Collection Philip Johnson,
New Canaan, Connecticut

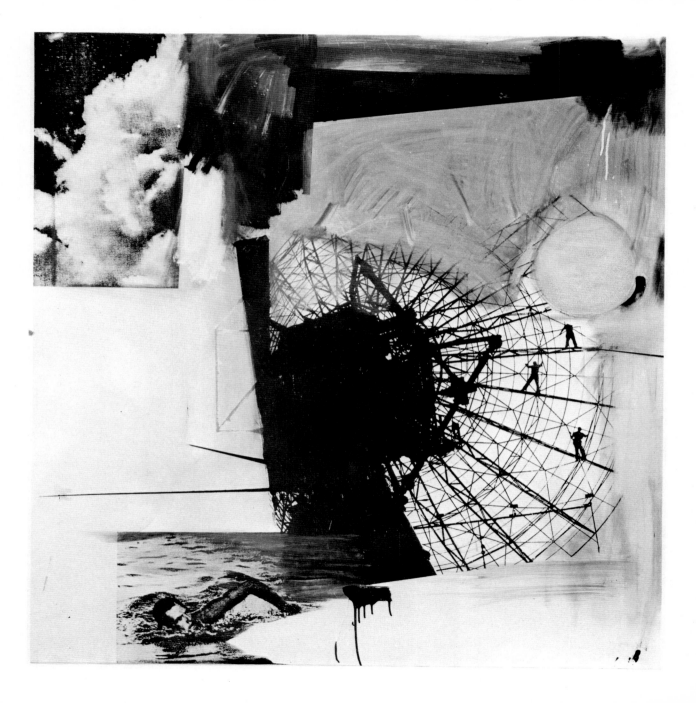

36. *Sundog*. 1962.
Oil on canvas, 60 × 60″.
Collection William Janss,
Beverly Hills, California

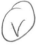

37. *Crocus*. 1962. Oil on canvas, 60 × 36″.
Leo Castelli Gallery, New York

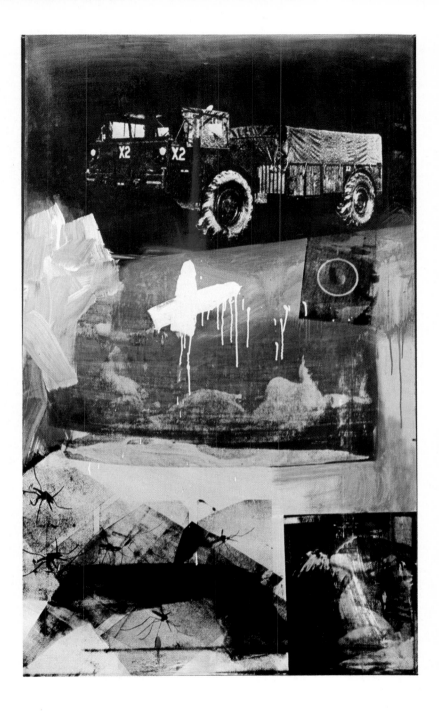

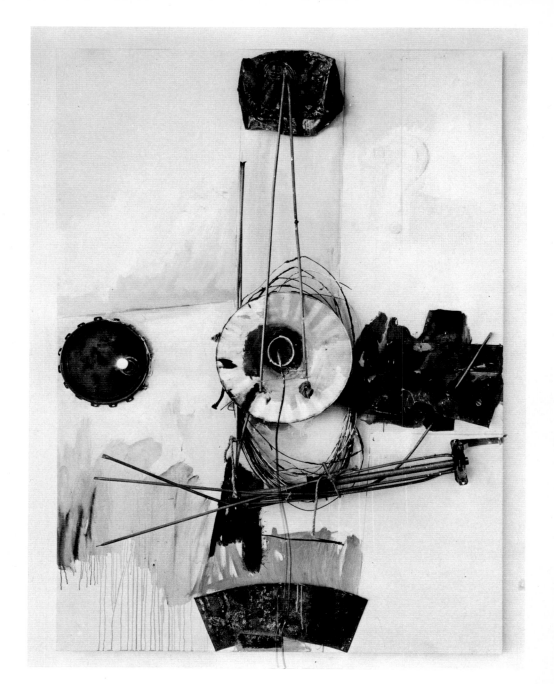

38. *Navigator*. 1962.
Combine painting, 84 × 60″.
Leo Castelli Gallery, New York

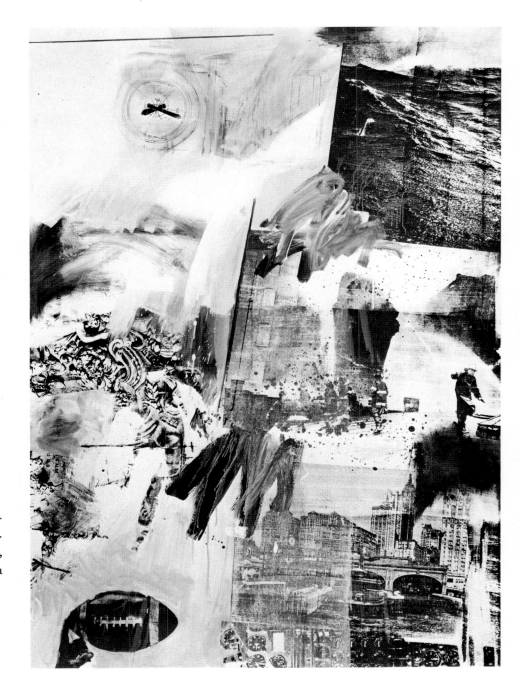

39. *Tideline*. 1963.
Oil on canvas, 84 × 60″.
Collection Mr. and Mrs. Max Monarch,
Altoona, Pennsylvania

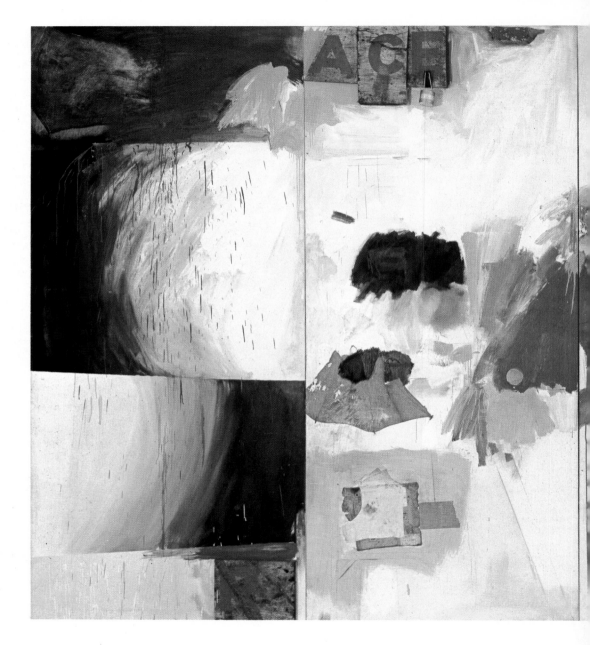

40. *Ace.* 1962.
Combine painting, 9 × 20′.
Albright-Knox Art Gallery,
Buffalo, New York.
Gift of Seymour H. Knox

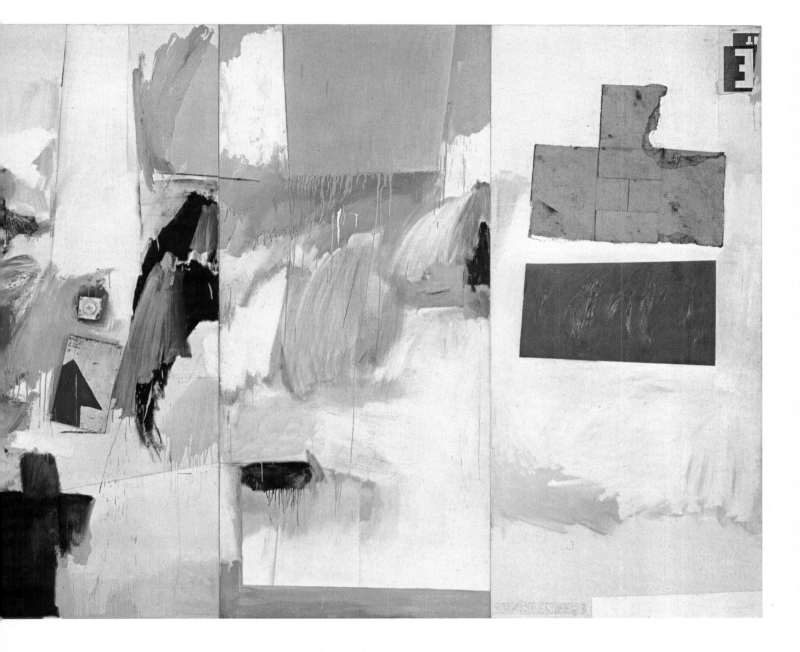

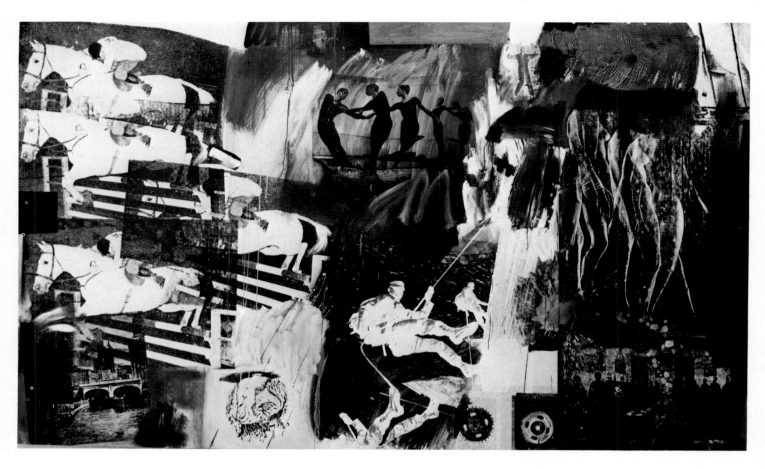

41. *Express.* 1963. Oil on canvas, 6 × 10′. Collection Mr. and Mrs. Charles B. Benenson, New York

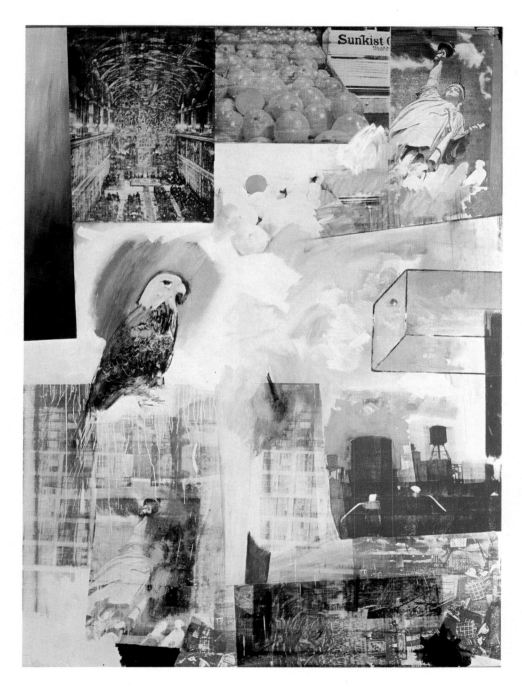

42. *Windward.* 1963.
Oil on canvas, 96 × 70".
Collection Mr. and Mrs.
Burton Tremaine,
Meriden, Connecticut

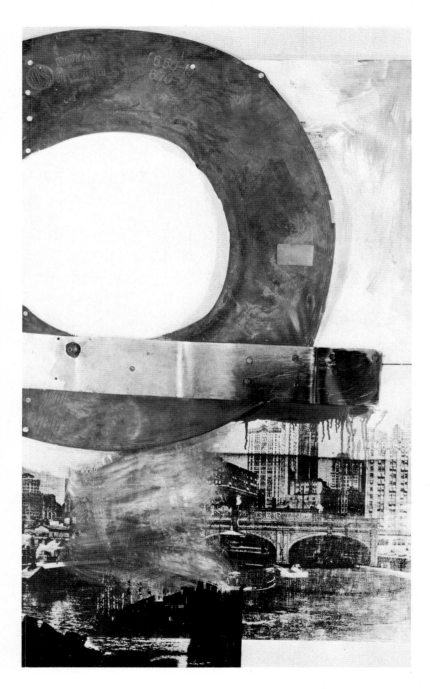

43. *Tadpole*. 1963. Combine painting, 48 × 30 1/4″.
Collection Mr. and Mrs. Stedman B. Noble,
Washington, D.C.

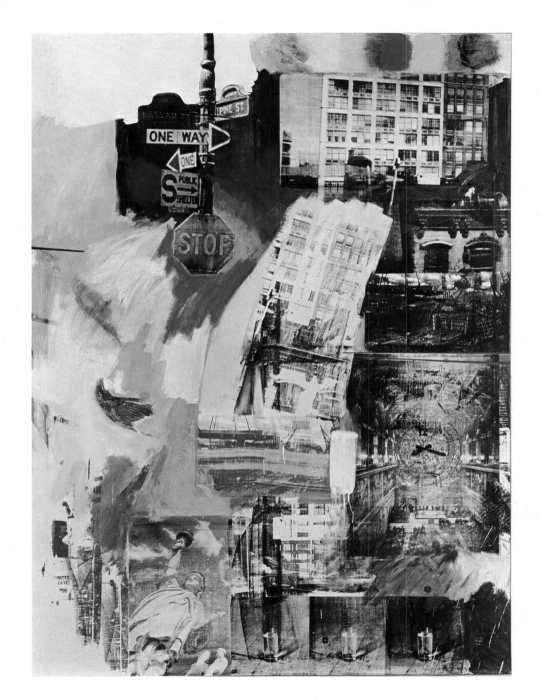

44. *Estate*. 1963.
 Oil on canvas, 96 × 70″.
 The Philadelphia Museum of Art

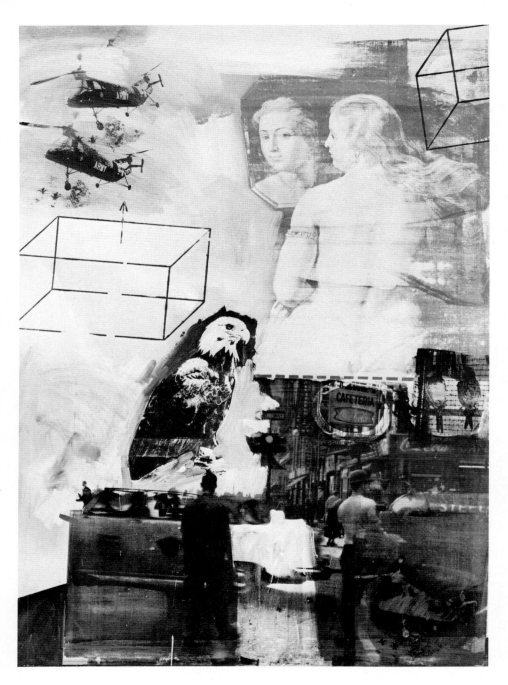

45. *Tracer*. 1964. Oil on canvas
with silk screen, 84 × 60″.
Collection Mr. and Mrs.
Frank M. Titelman,
Altoona, Pennsylvania

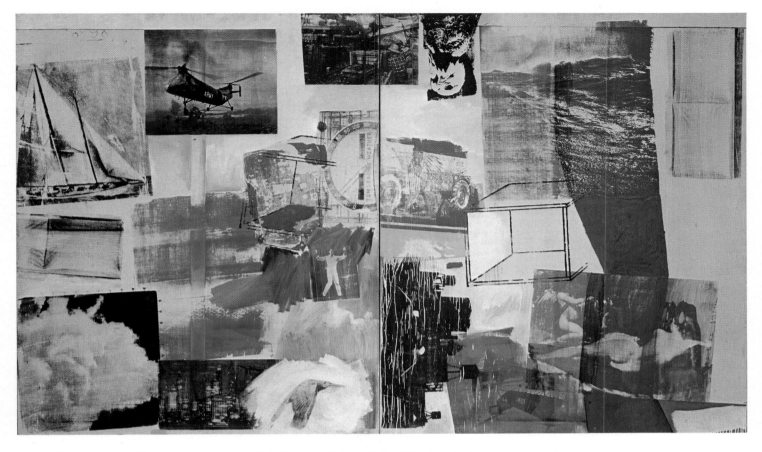

46. *Bicycle*. 1963. Oil on canvas, 6 × 10'. Collection Prince Sadruddin Aga Kahn, Geneva ✓

Overleaf: 47. *Oracle*. 1965. Mixed media construction in five parts.
Collection the artist

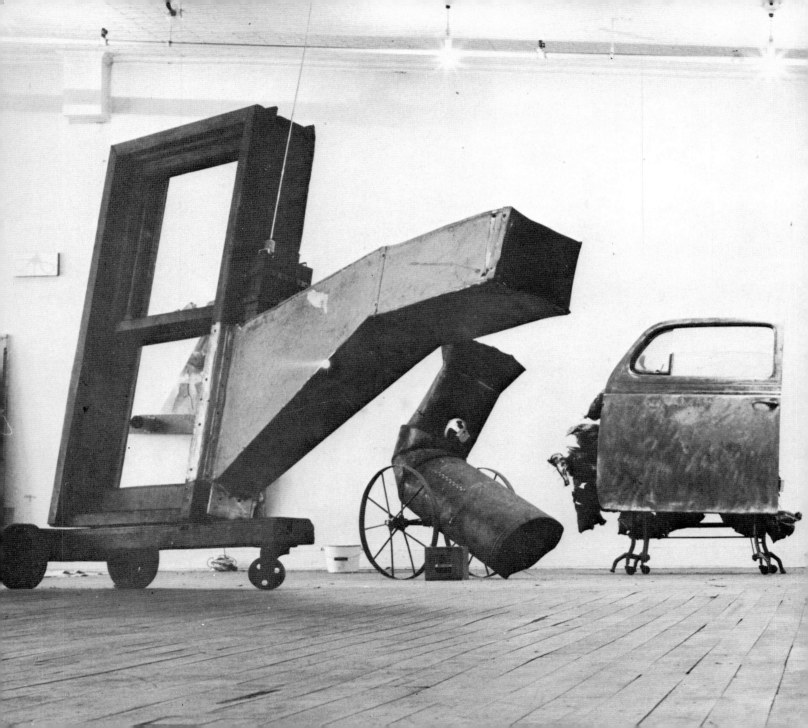

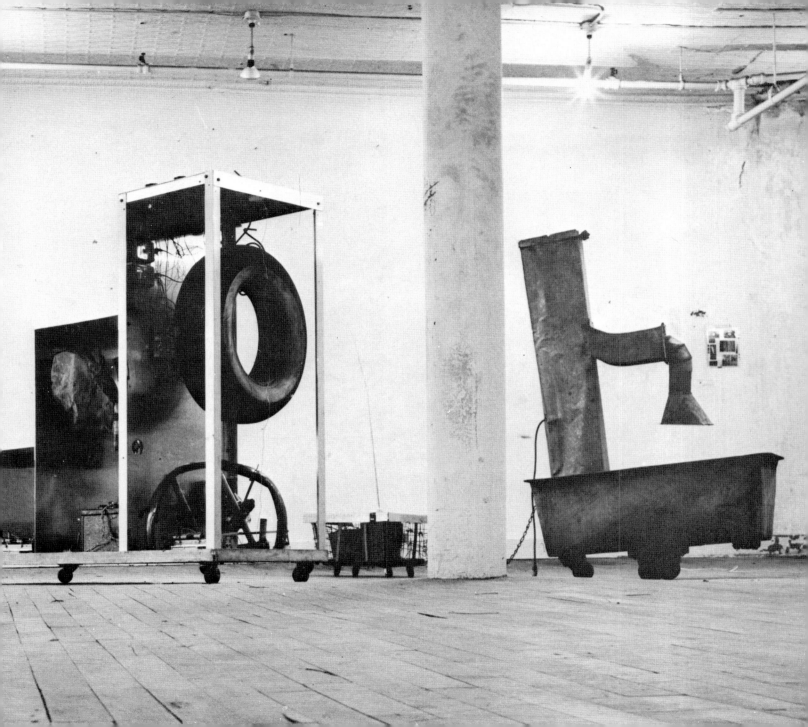

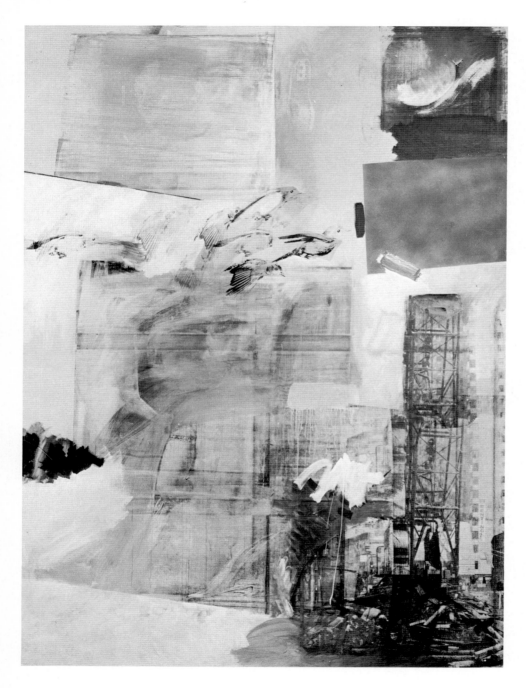

48. *Flush*. 1964. Oil on canvas
with silk screen, *96 × 72″*.
The Woodward Foundation of
Washington, D.C.

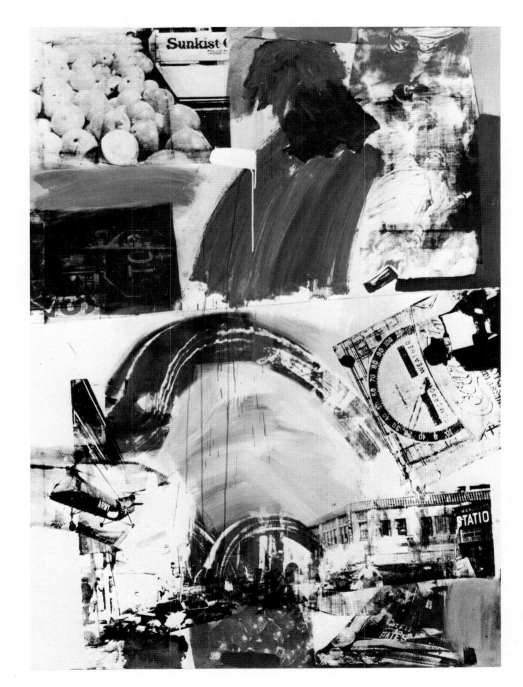

49. *Harbor.* 1964.
Oil on canvas with silk screen, 84 × 60".
Galerie Rudolf Zwirner,
Cologne, Germany

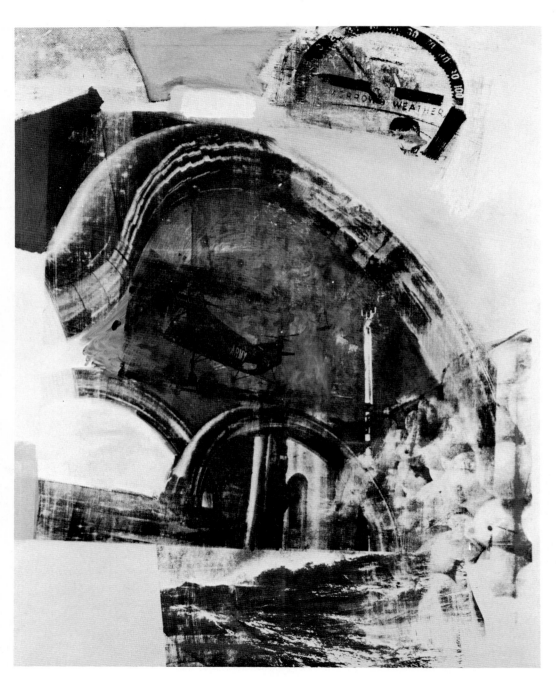

50. *Hedge.* 1964.
Oil on canvas with silk screen,
60 × 48″.
Collection Peter and
Irene Ludwig,
Aachen, Germany

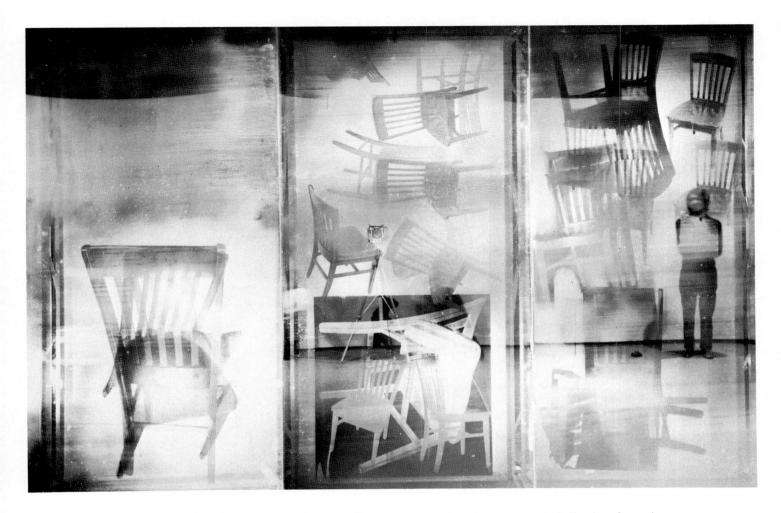

51. *Soundings*. 1968. Plexiglas silk screen and electronically controlled lights, 8 × 36 × 6′. Collection the artist

Autobiography

PORT ARTHUR TEXAS OCT. 22, 1925. MOTHER: DORA. FATHER: ERNEST (GRANDPARENTS):
HOLLAND DUTCH, SWEDISH, GERMAN, CHEROKEE. DE QUEEN GR. SCH., WOODROW
WILSON JR. H. SCH., THOMAS JEFFERSON H. SCH. GRAD. 1942./U. OF TEX. $^1/_2$ YR. U.S.
NAVY 2 $^1/_2$ YRS. NEUROPSYCHIATRIC TECH. FAMILY MOVED TO LAFAYETTE LA. WITH
SISTER, JANET, BORN APR. 23, 1936. AFTER NAVY: RETURNED HOME, LEFT HOME.
WORKED IN LOS ANGELES. MOVED TO KANSAS CITY TO STUDY PAINTING K.C.A.I.
WENT TO PARIS, 1947, MET SUE WEIL. STD. ACAD. JULIAN. 1948 BLACK MOUNTAIN
COLLEGE N.C. DISCIPLINED BY ALBERS. LEARNED PHOTOGRAPHY. WORKED HARD
BUT POORLY FOR ALBERS. MADE CONTACT WITH MUSIC AND MODERN DANCE. FELT
TOO ISOLATED, SUE AND I MOVED TO NYC. WENT TO ART STUDENTS LEAGUE. VYTLACIL
& KANTOR. BEST WORK MADE AT HOME. WHT. PAINTING WITH NO.'S BEST EXAMPLE.
SUMMER 1950, OUTER ISLAND CONN. MARRIED SUE WEIL. CHRISTOPHER (SON)
BORN JULY 16, 1951 IN NYC. FIRST ONE MAN SHOW BETTY PARSONS: PAINTINGS MOSTLY
SILVER & WHT. WITH CINEMATIC COMPOSITION. ALL PAINTINGS DESTROYED
IN TWO ACCIDENTAL FIRES. SUMMER BLK. MT. COLL. N.C. STARTED ALL BLK. & ALL WHT.
PAINTINGS. WINTER DIVORCED. SUE & CHRISTOPHER LIVING IN NYC. I WENT TO
ITALY WITH PAINTER & FRIEND CY TWOMBLY. RAN OUT OF MONEY IN ROME. TOOK
CHANCE GETTING JOB IN CASABLANCA AT ATLAS CONSTRUCTION CO. WORKED 2 MO.
GOT SICK, LEFT. TRAVELED FR. & SP. MOROCCO. RETURNED TO ROME. WHILE
TRAVELING CONSTRUCTED ROPE OBJECTS & BOXES. SHOWED IN ROME & FLORENCE.
CRITIC IN FLORENCE SAID WORK SHOULD BE THROWN IN THE ARNO. I DID. RETURNED TO
NYC 1952. LOFT ON FULTON STREET. MADE GROWING DIRT PAINTINGS. SHOW OF ALL
WHT. & ALL BLK. PAINTINGS AND ELEMENTAL SCULPTURE MADE FROM ROCKS, WOOD &
ROPE. CLOSEST FRIENDS AT THIS TIME DANCERS AND MUSICIANS. FEW PAINTERS.
BEGAN DOING THEATER WORK WITH MERCE CUNNINGHAM AND PAUL TAYLOR. BLK. &
WHT. SHOW AT STABLE NYC 1953 MISUNDERSTOOD AS GESTURES &
ANTIPAINTINGS. THE WHT. PAINTINGS WERE OPEN COMPOSITION BY RESPONDING TO

THE ACTIVITY WITHIN THEIR REACH. BEGAN RED PAINTINGS USING COMIC STRIPS AS COLOR GROUND. INCLUDED LIGHTS AND REFLECTORS. 1956 HAD SHOW EGAN GALL. NYC. NEW YEAR'S DAY HAD A FELDMAN CONCERT WITH PAINTINGS. "CHARLENE" LARGEST AND LAST EXAMPLE OF RED PICTURES. EARNED LIVING BY DOING FREE LANCE JOBS IN DISPLAY MOSTLY FOR GENE MOORE. BEGAN A SERIES IN "CROWD" COLOR, INSISTING THE OBJECT MATERIAL KEEP ITS IDENTITY. PAINTINGS BECAME AWKWARD PHYSICALLY, BEGAN BEING FREE STANDING: COMBINES. STUFFED ANIMALS. BED. SHOES. WROTE FUGUE TYPE PLAYS AND WORD SPOKEN MUSIC; NEVER PERFORMED. MOVED TO PEARL STREET OFF FULTON. JASPER JOHNS LIVED IN THE SAME BUILDING AND HAD JUST PAINTED HIS FIRST FLAG. IT WOULD BE DIFFICULT TO IMAGINE MY WORK AT THAT TIME WITHOUT HIS ENCOURAGEMENT. JOHN CAGE WAS ALSO A GENEROUS SOURCE OF INSPIRATION. IT WAS A RICH EXCHANGE. REBUS, WAGER, HYMNAL, ODALISK, CANYON, COCA COLA PLAN, CURFEW, SATELLITE WERE ALL DONE IN THE NEXT COUPLE OF YEARS. 1958 SHOW AT LEO CASTELLI. JASPER JOHNS, EMILE DE ANTONIO AND I POOLED FUNDS, MADE JOHN CAGE 20 YR. RETROSPECTIVE CONCERT AT TOWN HALL NYC. MOVED TO FRONT ST. OFF WALL. TROPHY I, MONOGRAM, BROADCAST, ALLEGORY, 4 SUMMER RENTALS, PILGRIM, 2 1/2 YRS. MAKING 34 DRAWINGS FOR DANTE'S INFERNO, THE LAST 6 MO. IN FLORIDA. ISOLATION NEEDED FOR CONCENTRATION. I BECAME THE LIGHTING MAN & DESIGNER FOR MERCE CUNNINGHAM DANCE CO. SUMMERSPACE, CRISES, ANTIC MEET, WINTERBRANCH, FIELD DANCES, NOCTURNES, SPRING WEATHER & PEOPLE, PAIRED, SUITE, CHANGLING, NIGHT WANDERING, & STORY. LOCAL TOURING WITH DANCE CO. WAS AWKWARD, BUT BEAUTIFUL ADDITION TO MY WORK. THE DANCES, THE DANCERS, THE COLLABORATION, THE RESPONSIBILITIES AND TRUST WHICH ARE ESSENTIAL IN COOPERATIVE ART BECAUSE THE MOST IMPORTANT & SATISFYING ELEMENT IN MY LIFE WORKED POSITIVELY WITH THE PRIVATENESS AND LONELINESS OF PAINTING. CAROLYN BROWN, VIOLA FARBER & STEVE PAXTON INSPIRED ME TO THE CHALLENGE OF DESERVING THEIR LOVE AND CONFIDENCE. FIRST ONE MAN SHOW OF PAINTINGS IN EUROPE, GALERIE DANIEL CORDIER, PARIS. FIRST ONE MAN SHOW IN

ITALY, GALLERIA DELL' ARIETE. TRIP TO STOCKHOLM. AMERICAN EMBASSY, PARIS:
"COLLABORATION FOR DAVID TUDOR" ME, NIKI DE ST. PHALLE, JASPER JOHNS, JEAN
TINGUELY & DAVID TUDOR. TIME PAINTINGS, FIRST LANDING JUMP, BLUE EAGLE, BLUE
EXIT, RIGGER, PANTOMIME, TROPHY II & III, BLACK MARKET, WALL STREET, SLUG,
RESERVOIR, FLOOR PIECES: EMPIRE I & II, AEN FLOGA, RED ROCK, 19346, TROPHY IV, (BLUE
LIGHT BULBS, BY MICHAEL McCLURE). STARTED LITHOGRAPHY, UNIVERSAL LTD.
ART EDITIONS, TANYA GROSMAN, LONG ISLAND. BIG INFLUENCE ON PAINTINGS.
"THE CONSTRUCTION OF BOSTON," A COLLABORATION BY NIKI DE ST. PHALLE,
KENNETH KOCH, JEAN TINGUELY & ME, DIR. BY MERCE CUNNINGHAM, NYC. STARRING,
WITH COLLABORATORS, OYVIND FAHLSTROM, FRANK STELLA, BILLY KLUVER, STEVE
PAXTON, VIOLA FARBER & HENRY GELDZAHLER. MOVED TO BROADWAY & 12TH
ST. BEGAN "ORACLE," A FIVE PIECE SCULPTURE WITH REMOTE CONTROL SOUND
AND FOUNTAIN. COLLABORATOR BILLY KLUVER ASSISTED BY HAROLD HODGES.
"ORACLE" INTERRUPTED BY "DYLABY" IN AMSTERDAM, SANDBURG, DIR. OF STEDELIJK.
MET MARCEL RAYESSE & PER ULTVEDT. ACE, STRIPPER, CARTOON, TROPHY V. BEGAN SILK
SCREEN PAINTINGS TO ESCAPE FAMILIARITY OF OBJECTS & COLLAGE. BARGE, DRY RUN,
SUNDOG, QUARRY, BRACE, SHORTSTOP, OVERCAST I, II, III, STRAWBOSS, CROCUS,
EXILE, GLIDER, CALENDAR, BUOY, GIFT FOR ILEANA, PAYLOAD, ARCHIVE, ESTATE,
MANUSCRIPT, OVERDRIVE, BAIT, KITE, DIE HARD, DRY RUN, TADPOLE, COVE, EXPRESS,
JUNCTION, ROUNDTRIP, BICYCLE, TRANSOM, SPOT, SHAFTWAY, TIDELINE, STAR GRASS,
STOP GAP, TRELLIS, DRY CELL, WOODEN GALLOP. WORKED WITH JUDSON GROUP,
THEATRE/DANCE. WORKSHOP EXPERIMENTAL EXCHANGE. LIGHTING FOR YVONNE
RAINER'S "TERRAIN." 1ST PRIZE 5TH INTERNATIONAL EXHIBITION OF PRINTS,
LJUBLJANA, YUGO. SHOW AT GALERIE ILEANA SONNABEND, PARIS. ILEANA IS A
SPECIAL PERSON. FIRST DANCE/THEATER PIECE: "PELICAN" WASHINGTON, D.C. 1963.
CAROLYN BROWN, P. ULTVEDT & ME. CAROL ON POINTE, MEN ON ROLLER SKATES.
SOUND: COLLAGED; RADIO, RECORD, MOVIE, T.V. SOURCE. ALICE DENNEY, PROD. JEWISH
MUSEUM COMPREHENSIVE SURVEY SHOW. FIRST GOY IN NEW WING. ALAN SOLOMON,
DIR. SURPLUS DANCE THEATER; ARTISTS: LUCINDA CHILDS, JUDITH DUNN, ALEX HAY,

DEBORAH HAY, ROBERT MORRIS, YVONNE RAINER, ALBERT REED, STEVE PAXTON & ME.
"SHOT PUT" DANCE IN DARKNESS WITH FLASHLIGHT ON RIGHT FOOT. MUSIC
EXCERPT FROM "SWEDISH BIRD CALLS" BY OYVIND FAHLSTROM. STEVE PAXTON, PROD.
FLUSH, TRACER, PERSIMMON, RETROACTIVE I & II, BUFFALO, SKYWAY, CHOKE, STUNT,
TRAPEZE, WHALE, PRESS, HARBOR, QUOTE, TREE FROG, CREEK, ROUND SUM, HEDGE,
LOCK, TRAP. WHITECHAPEL SHOW (RETROSPECTIVE) LONDON, BRYAN
ROBERTSON, DIR. BROKE ATTENDANCE RECORDS. INCLUDED DANTE DRAWINGS.
WENT TO LONDON BEFORE OPENING, MET LONDON ARTISTS & MADE B.B.C. T.V.
SPECIAL. WORLD TOUR WITH MERCE CUNNINGHAM & DANCE CO. AS TECH.
SOME OF THE SETS & COSTUMES HAD TO BE MADE IN THE PARTICULAR ENVIRONMENT,
NOT TO BE DUPLICATED. THE LIGHTING WAS DONE SPONTANEOUSLY BECAUSE OF
ESTHETICS & PRACTICALITY. STRASBOURG, PARIS, BOURGES, VENICE (WHILE WE WERE
THERE I WON THE 1ST PRIZE AT THE VENICE BIENNALE.) VIENNA, MANNHEIM, ESSEN,
COLOGNE, LES BAUX, DARTINGTON, LONDON, STOCKHOLM (EXTRA CONCERT:
DEBORAH HAY, STEVE PAXTON, ALEX HAY, OYVIND FAHLSTROM, DAVID
TUDOR & ME. "ELGIN TIE," DUET WITH SWEDISH COW.), TURKU, HELSINKI, PRAGUE,
OSTRAVA, WARSAW, POZNAN, KREFELD, BRUSSELS, ANTWERP, SCHEVENINGEN/DEN
HAAG, BOMBAY, AHMEDABAD, CHANDIGARH, NEW DELHI, BANGKOK,
TOKYO (EXTRA CONCERT. EXCHANGE: JAPANESE/AMERICAN. 10 JAPANESE
PAINTERS, MUSICIANS, DANCERS & DEBORAH HAY, STEVE PAXTON, ALEX HAY, & ME.)
KOBE, OSAKA. END OF TOUR I STOPPED IN HAWAII. AMAZING. ABRAMS PUBLISHES
DANTE ILLUSTRATIONS. MORE LITHOS; UNIVERSAL LTD. ART EDITIONS. DRAWING
SHOW DWAN GALLERY LOS ANGELES. FOSSIL FOR BOB MORRIS, N.Y. BIRDCALLS FOR
OYVIND FAHLSTROM, SLEEP FOR YVONNE RAINER. FINISHED "ORACLE" (1965). REAL
WORK IN PROGRESS, IMPROVED EQUIPMENT & INFO. 1ST PRIZE CORCORAN BIENNIAL,
WASHINGTON, D.C., "AXLE." DANCE/THEATRE PIECES: "SPRING TRAINING" SKETCH FOR
A.F.A. IN BOSTON. FIRST N.Y. THEATER RALLY ARTISTS: CAROLYN BROWN, TRISHA BROWN,
JIM DINE, JUDITH DUNN, DAVID GORDON, ALEX HAY, DEBORAH HAY, TONY HOLDER,
ROBERT MORRIS, THE ONCE GROUP, CLAES OLDENBURG, STEVE PAXTON, YVONNE

RAINER, ROBERT WHITMAN & ME. PROD. BY STEVE PAXTON & ALAN SOLOMON, INC.
"DARK HORSE" A CONCERT BY ALEX, DEBORAH & ME SUPERIMPOSED ON FINAL 3
DANCE CONCERTS OF RALLY. (I DID PELICAN, ALEX HAY REPLACING ULTVEDT, AND
SPRING TRAINING IN FULL WITH CHRISTOPHER R. DEBUTING WITH 23 TURTLES
WITH LIGHTS ON THEIR BACKS FOR ORGANIC LIGHTING.) MAP ROOM II FOR
CINEMATHEQUE. 1966 MUSEUM MOD. ART DANTE DRAWINGS SHOW. 3 CONCERTS FOR
L.A. COUNTY MUSEUM OF ART. THEATER PIECE FOR WASHINGTON, D.C. "NOW
FESTIVAL." "LINOLEUM" SIMONE WHITMAN, DEBORAH HAY, STEVE PAXTON, ALEX HAY,
CHRISTOPHER & JILL DENNEY. LINOLEUM TELEVIZED FOR CH. 13 NYC USING
SUPERIMPOSITIONS WITH MIXER. 9 EVENINGS OF ART & TECHNOLOGY AT 69TH REG.
ARMORY. A COLLABORATION BETWEEN ARTISTS & SCIENTISTS & TECHNOLOGY
"OPEN SCORE" WITH A CAST OF 500 &, AND CLOSED CIRCUIT INFRA RED T.V.
PROJECTION, A TENNIS MATCH IN CONTROL OF THE LIGHTS. THE BEGINNING OF E.A.T.,
EXPERIMENTS IN ART & TECHNOLOGY TO FUNCTION AS A CATALYST FOR THE
INEVITABLE FUSING OF SPECIALIZATIONS CREATING A RESPONSIBLE MAN WORKING
IN THE PRESENT.

Bibliography

BOOKS

Amaya, Mario. *Pop Art . . . and After*. New York, Viking Press, 1965.

Ashton, Dore. *Rauschenberg: XXXIV Drawings for Dante's Inferno*. New York, Harry N. Abrams, 1964.

Dienst, Rolf-Günter. *Pop Art. Eine kritische Information*. Wiesbaden, Limes, 1965.

Hunter, Sam. "American Art Since 1945," in *New Art Around the World: Painting and Sculpture*. New York, Harry N. Abrams, 1966.

Kultermann, Udo. *Neue Dimensionen der Plastik*. Tübingen, Wasmuth, 1967.

Myers, David. "Robert Rauschenberg," in *School of New York: Some Younger Artists* (Bernard Harper Friedman, ed.). New York, Grove Press, 1959.

Pellegrini, Aldo. *New Tendencies in Art*. New York, Crown, 1966.

Rose, Barbara. *American Art Since 1900. A Critical History*. New York, Praeger, 1967.

Rosenberg, Harold. *The Anxious Object; Art Today and Its Audience*. New York, Horizon Press, 1964.

Scholz-Wanckel, Katharina. *Pop Import. Eine selektive Abhandlung über Pop Artisten*. Hamburg, Matari, 1965.

Tomkins, Calvin. *The Bride & the Bachelors; the Heretical Courtship in Modern Art*. New York, Viking Press, 1965.

PERIODICALS

Alfieri, Bruno. "Diario Critico, II: Dopo il complesso d'inferiorità di New York con Parigi (1900–1963) ecco il complesso di Parigi con New York malgré De Gaulle (intanto Londra cresce)," *Metro*, 10, October, 1965.

Ashton, Dore. "Art," *Arts & Architecture*, LXXVIII, 2, February, 1961.

———. "Rauschenberg's Thirty-four Illustrations for Dante's Inferno," *Metro*, 2, May, 1961.

———. "The Collaboration Wheel: A Comment on Robert Rauschenberg's Comment on Dante," *Arts & Architecture*, LXXX, 12, December, 1963.

———. "New York Commentary: Object versus Illusion," *Studio*, CLXVII, 849, January, 1964.

Bannard, Darby. "Present-Day Art and Ready-Made Styles. In Which the Formal Contribution of Pop Art is Found to be Negligible," *Artforum*, V, 4, December, 1966.

Berkson, William. "In the Galleries. Robert Rauschenberg," *Arts Magazine*, XXXIX, 10, September–October, 1965.

Cage, John. "On Robert Rauschenberg, Artist, and His Work," *Metro*, 2, May, 1961.

Calas, Nicolas. "Continuance. On the Possibilities of a New Kind of Symbolism in Recent American Painting and What Such Symbols Could Possibly Mean," *Art News*, LVII, 10, February, 1959.

Clay, Jean. " 'Art . . . Should Change Man,' " *Studio International*, CLXXI, 875, March, 1966.

Dorfles, Gillo. "Rauschenberg, or Obsolescence Defeated," *Metro*, 2, May, 1961.

Forge, Andrew. "Robert Rauschenberg," *New Statesman*, LXVII, February 21, 1964.

Gassiot-Talabot, Gérald. "La Figuration narrative dans la peinture contemporaine," *Quadrum*, XVIII, 1965.

Hamilton, George Heard. "Painting in Contemporary America," *The Burlington Magazine*, CII, 686, May, 1960.

Johnson, Ellen H. "The Image Duplicators—Lichtenstein, Rauschenberg and Warhol," *Canadian Art*, XXIII, 1, January, 1966.

Johnson, Philip. "Young Artists at the Fair and at Lincoln Center," *Art in America*, LII, 4, August, 1964.

Johnston, Jill. "Reviews and Previews: Robert Rauschenberg, Jean Tinguely, Niki de Saint-Phalle," *Art News*, LXI, 4, Summer, 1962.

Jouffroy, Alain. "Rauschenberg ou le déclic mental," *Aujourd'hui. Art et Architecture*, 38, September, 1962.

———. "R. Rauschenberg," *L'Oeil*, 113, May, 1964.

———. "Une révision moderne du sacré," *XXᵉ siècle*, XXVI, 24, December, 1964.

Kaprow, Allan. "Experimental Art," *Art News*, LXV, 1, March, 1966.

Kelly, Edward T. "Neo-Dada: A Critique of Pop Art," *The Art Journal*, XXIII, 3, Spring, 1964.

Legrand, Francine-Claire. "En marge de Documenta II: La peinture et la sculpture au défi," *Quadrum*, VII, 1959.

Lippard, Lucy R. "The Silent Art," *Art in America*, LV, 1, January–February, 1967.

Macorini, E. "Le illustrazioni di Rauschenberg per l'Inferno di Dante," *Domus*, 431, October, 1965.

Nordland, Gerald. "Neo-Dada Goes West," *Arts Magazine*, XXXVI, 9, May–June, 1962.

Novick, Elisabeth. "Happenings in New York. Staged by the First New York Theatre Rally," *Studio International*, CLXXII, 881, September, 1966.

Oeri, Georgine. "The Object of Art," *Quadrum*, XVI, 1964.

Picard, Lil. "Ausstellungen in New-York. Bei Rauschenberg nichts Neues," *Das Kunstwerk*, XX, 9–10, June–July, 1967.

Plagens, Peter. "Present-Day Styles and Ready-Made Criticism. In Which the Formal Contribution of Pop Art is Found to be Minimal," *Artforum*, V, 4, December, 1966.

Restany, Pierre. "Die Beseelung des Objektes," *Das Kunstwerk*, XV, 1–2, July, 1961.

———. "La XXXII Biennale di Venezia, Biennale della irregolarità," *Domus*, 417, August, 1964.

———. "L'art contemporain entre deux pôles: Pop et Op," *La Galerie des Arts*, 30, December, 1965–January, 1966.

Revel, Jean-François. "XXXIIᵉ Biennale de Venise. Triomphe du 'Réalisme Nationaliste.' " *L'Oeil*, 115–16, July–August, 1964.

Roberts, Keith. "Current and Forthcoming Exhibitions London," *The Burlington Magazine*, CVI, 732, March, 1964.

Rose, Barbara. "Dada Then and Now," *Art International*, VII, 1, January, 1963.

———. "The Second Generation: Academy and Break-

through," *Artforum*, IV, 1, September, 1965.

Seckler, Dorothy Gees. "The Artist Speaks: Robert Rauschenberg," *Art in America*, LIV, 3, May–June, 1966.

Solomon, Alan. "American Art between Two Biennales," *Metro*, 11, June, 1966.

Swenson, G. R. "Rauschenberg Paints a Picture," *Art News*, LXII, 2, April, 1963.

———. "Peinture américaine 1946–1966," *Aujourd'hui. Art et Architecture*, 55–56, January, 1967.

Zerner, Henri. "Universal Limited Art Editions," *L'Oeil*, 120, December, 1964.

Zevi, Bruno. "Architettura e pop-art," *L'architettura*, X, 9, January, 1965.